IMAGES
of America
GADSDEN COUNTY

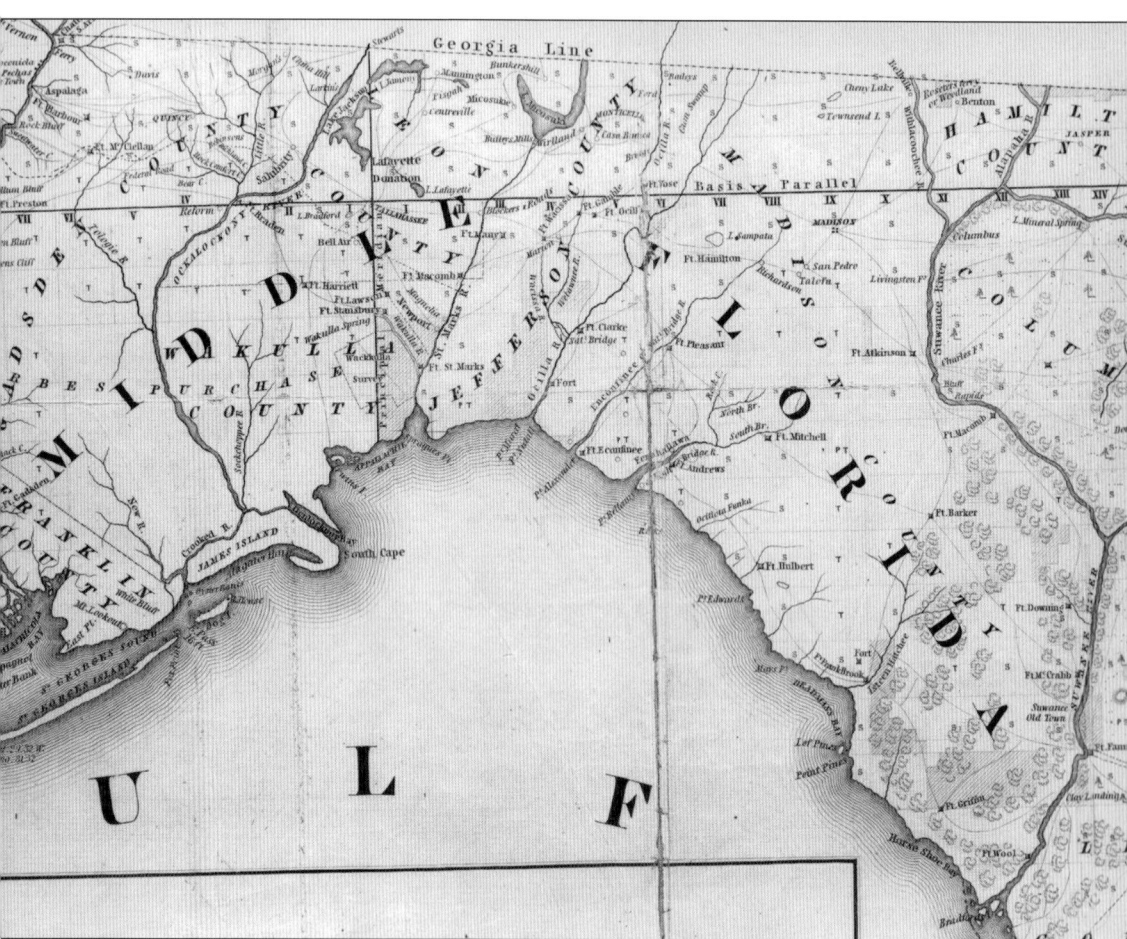

Gadsden County's original borders stretched from the Apalachicola River to the Suwannee River, and from the Georgia state line to the Gulf of Mexico. Also known as Middle Florida, Gadsden County was eventually divided into the counties of Gadsden, Leon, Jefferson, Madison, Liberty, Franklin, and Wakulla. This 1846 map shows the area of Gadsden County crisscrossed by Indian trails, wagon roads, the Federal Highway, and the old mission trail now known as US Highway 90. (GCHS.)

ON THE COVER: Following the disastrous 1907 tobacco harvest, 12 major tobacco packing and growing concerns merged into the American Sumatra Tobacco (AST) Corporation. The merger began a new era in the shade tobacco industry in Gadsden County. By 1910, AST controlled nearly all of the tobacco production in the region. Its vast holdings included more than 30,000 acres, 40 farms, packinghouses, and hundreds of workers, making it the county's largest employer. (GCHS.)

IMAGES of America
GADSDEN COUNTY

David A. Gardner, Joseph F. Munroe,
and Dawn M. McMillan

ARCADIA
PUBLISHING

Copyright © 2012 by David A. Gardner, Joseph F. Munroe, and Dawn M. McMillan
ISBN 978-0-7385-9097-4

Published by Arcadia Publishing
Charleston, South Carolina

Printed in the United States of America

Library of Congress Control Number: 2012949197

For all general information, please contact Arcadia Publishing:
Telephone 843-853-2070
Fax 843-853-0044
E-mail sales@arcadiapublishing.com
For customer service and orders:
Toll-Free 1-888-313-2665

Visit us on the Internet at www.arcadiapublishing.com

In 1975, a young scholar undertook the daunting challenge to write Gadsden County's history. He succeeded. In gratitude, we dedicate this to Miles Kenan Womack Jr.

Contents

Acknowledgments		6
Introduction		7
1.	The Beginnings	9
2.	Sense of Place	13
3.	Cabins to Castles	53
4.	Hospitals and Medicine	75
5.	Churches and Schools	79
6.	Rural Life	97
7.	Transportation and Industry	101
8.	Social Life and Leisure	113
9.	Gadsden Connections	125
Gadsden County Honor Roll		127

Acknowledgments

We have been fortunate to have access to many private and public archives. The definitive work, *Gadsden: A Florida County in Word and Picture*, by Miles Kenan Womack Jr., has been a primary source and must be acknowledged as the catalyst for the amazing treasury of Gadsden County photographs on file in the State Archives of Florida, Florida Memory collections (SAF/FM). We are also indebted to the University of Florida Digital Collections for access to their assortment of Sanborn Fire Insurance Maps of Florida. Archives held by the Gadsden County Historical Society (GCHS) and the Gadsden County FLGenWeb Project were shared, as were public papers, including Fire Chief Robert Joyner's "History of Fire Protection, Quincy, Florida." Access to private archives was generously granted by the families of Claire Munroe Bates, Mortimer B. Bates Jr., E.B. Embry, and Josephine Gossett Phillips. Sandra F. Whetstone shared the "History of the Joseph 'Little Joe' Fletcher Family" by Isabelle Suber and Hentz Fletcher, and local churches tolerated our inquires either in person or by phone. Many individuals were consulted and, if included, we've noted a credit for their generous contribution. We've shared our family archives, but we owe our greatest debt to the past and the voices guiding us from so long ago: Anne Virginia Curtis Davidson, Dr. Charles A. Hentz, Frank P. May, and many others who knew we would listen.

INTRODUCTION

The home we call Gadsden County is as much about emotion as it is about place. For many people, roots run deep, and crossing the county line may bring feelings of joy and anticipation as familiar landmarks pass by, and of contentment, knowing that one is finally "home." We think this emotion is shared, and our effort to document Gadsden County is only one page in a history full of collective memories.

Certainly, for centuries men have been attracted to the land's rolling hills, abundance of flowers, and ancient oaks draped in Spanish moss. Known as "Middle Florida," the county's original territory contained a vast wilderness of virgin timber bordered by the Suwannee and Apalachicola Rivers, Georgia, and the Gulf of Mexico. Spanish explorers encountered Native American villages along the rich lands of the Ochlockonee and Apalachicola Rivers where the Apalachee Indians farmed. In addition, Creeks settled between the Chattahoochee and Flint Rivers. In the 16th century, the Spanish established missions and armed garrisons east of the Apalachicola River, and native culture began to disappear.

Throughout the 17th and 18th centuries, Florida was the site of skirmishes between the Spanish and English colonials. Native Americans were recruited by both sides. By 1704, Spain abandoned all settlements in Middle Florida except for a fort on the Apalachicola River. Runaway slaves successfully escaped to the wilderness, pursued by Georgia's governor, James Oglethorpe. Florida would become a British territory before returning to Spanish control in 1783.

From the late 18th century through the first quarter of the 19th, Middle Florida became a haven for Native Americans, free blacks, fugitives, and fleeing slaves. Law enforcement was almost nonexistent, and the wilderness provided a refuge for Creek Indians drawn to the hunting grounds. There, they mixed freely with the escaped slaves and, collectively, the group became known as the Seminoles, an interpretation of the Spanish word *cimarron*, meaning "wild one" or "runaway."

After gaining independence, the United States established legal borders with Spanish Florida in the Treaty of San Lorenzo, signed on October 27, 1795. Surveyors from both countries progressed eastward to the junction of the Chattahoochee and Flint Rivers, but difficulties with the Seminoles terminated their activity. The surveys were abandoned. However, the border, as established in the treaty, was recognized as the official boundary.

Following the War of 1812, Gen. Andrew Jackson was given responsibility for defending the country's border against possible British infiltration. A British colonel, Edward Nicholls, established a fort near the mouth of the Apalachicola River south of the Spanish line after being routed from Pensacola by Jackson. Nicholls's fort was soon abandoned, but runaway slaves commandeered it, thereby controlling river traffic. Seen as a threat, US forces engaged the fort, firing a cannon. The ordnance exploded in a powder magazine, killing most inside. A period of restlessness, known as the Seminole Wars, soon followed, with the Seminoles engaging in guerilla tactics against the American military. Jackson was given permission by the United States to penetrate the Spanish border and hunt down the raiders.

Capt. James Gadsden, Jackson's aide-de-camp, recognized the strategic value of the destroyed fort's location and ordered it rebuilt. An aggressive campaign lessened the Seminole threat, supplanted the Spanish presence in Middle Florida, and established American military control over West Florida. Riding the crest of popular opinion, Jackson paved the way for the formal acquisition of Florida from Spain. On February 22, 1821, the United States signed the Adams-Onis Treaty, and Spanish Florida became a United States territory.

Prior to the acquisition of Florida, over 1,200,000 acres, known as the Forbes Purchase, had been accumulated by a trading firm that became the Apalachicola Land Company. Clear title to the land was given in exchange for debts owed the firm by Indians unable to pay. Recognized by the Spanish crown as legitimate, the United States Supreme Court confirmed the legality of the company's holdings in an 1836 ruling. With available land for sale and a US military presence established in what was still Spanish Florida, the settlers began arriving in 1820.

Among the earliest to arrive were pioneers in the Little River Survey of the Forbes Purchase. These men were homesteading by the time Andrew Jackson was appointed the first territorial governor. After Florida's division into several counties, a fifth, Gadsden County, named for James Gadsden, was created on June 24, 1823, under Gov. William Pope Duval. Its territorial limits were set, and the county seat, Quincy, was surveyed on May 26, 1825.

Since June 24, 1823, many pages of history and memory have passed. Traumatic events on a national scale have had an impact on a county economy that has been dependent on agriculture: a reliance on a labor force first based upon slavery and then on low-wage workers during the resurrection of tobacco in the decades following Reconstruction; the incredible growth of the county between the late 19th and early 20th centuries; and the demise of the shade tobacco industry in the 1970s that coincided with social change and economic uncertainty.

But progress exists. The only Florida county with a black majority elected its first African American sheriff, Morris Young, in 2004. Havana, once a ghost town, thrives as an antiques center. Quincy is home to the Gadsden Arts Center and the Quincy Music Theater, both important cultural attractions. The spectacular bluffs in Chattahoochee draw many visitors to boat races and concerts. And an alternative-energy industry is just beginning.

Recreational opportunities abound. Lake Talquin attracts sports fishermen from all over, and hunting is a popular pastime. Beautiful roads exist as the domain of national bicycle groups, and a trail system is proposed. Bear Creek Trails and Ravine in the Lake Talquin State Forest and Apalachicola Nature Trail draw many to view unique native species of trees and wildflowers, including mountain laurel.

Historic Quincy, shrouded in the Coca-Cola myth, features several buildings listed in the National Register of Historic Places. Bed and breakfast inns exist within the lovely antebellum neighborhoods, attracting visitors to the "Richest Small Town in America," a title made obsolete long ago.

Despite the contrasts in income, class, and education, there is a shared love for this special place. Realistically, this book is by no means a definitive history of Gadsden County. Instead, it is a lingering scent, or perhaps the melody from a song. The county has had an impact on many. Margaret Mitchell researched her antebellum roots here, a reality commemorating a county family in the opening chapter of *Gone with the Wind*. Almost 60 years later, an African American boy named Benjamin Knox grew up to become a key character, the Lady Chablis, immortalized in John Berendt's book *Midnight in the Garden of Good and Evil*. These links to two well-known books of the American South are fitting; as many say, "it must be in the water." So, to our readers, please sit back, take a sip, and enjoy Gadsden County, the place we call "Home."

One

THE BEGINNINGS

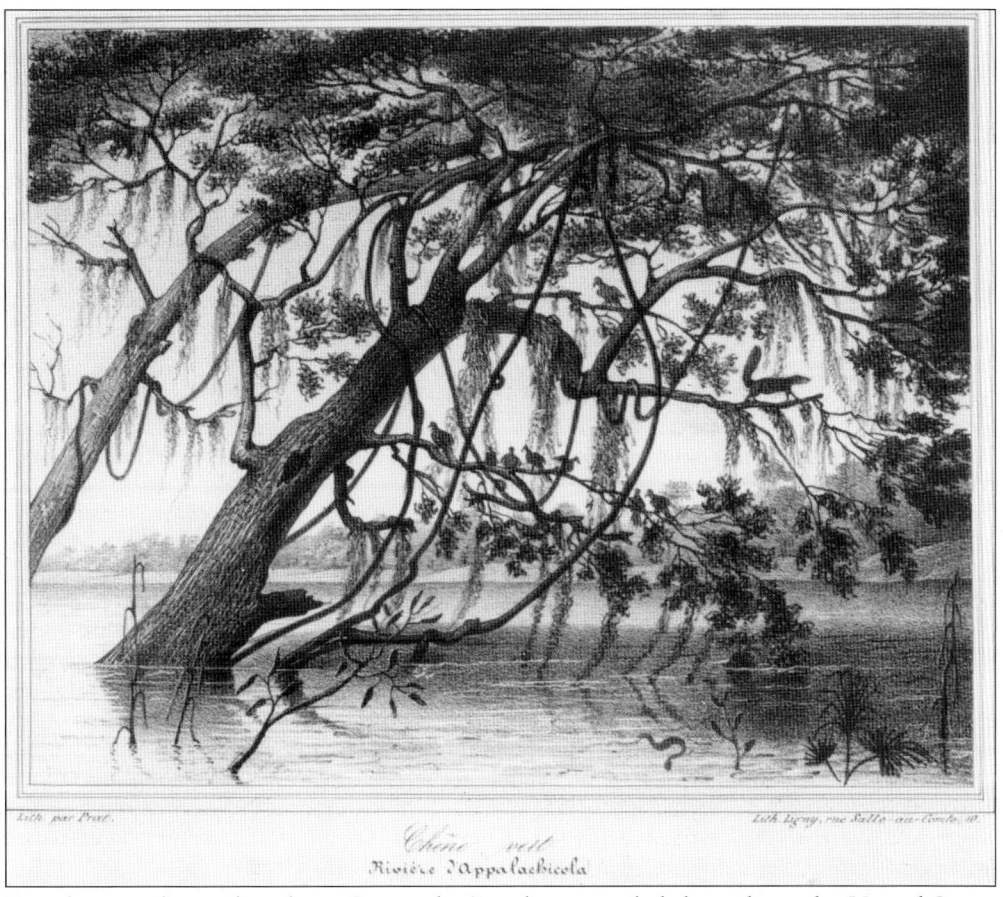

French naturalist and explorer Comte de Castelnau traveled throughout the United States and Canada from 1837 to 1841. His purpose was to provide an objective sociological report on North American races. In 1842, he created this sketch of the Apalachicola River. Many of his sketches were the earliest contemporary recordings of the area he visited, especially Georgia and Florida. (GCHS.)

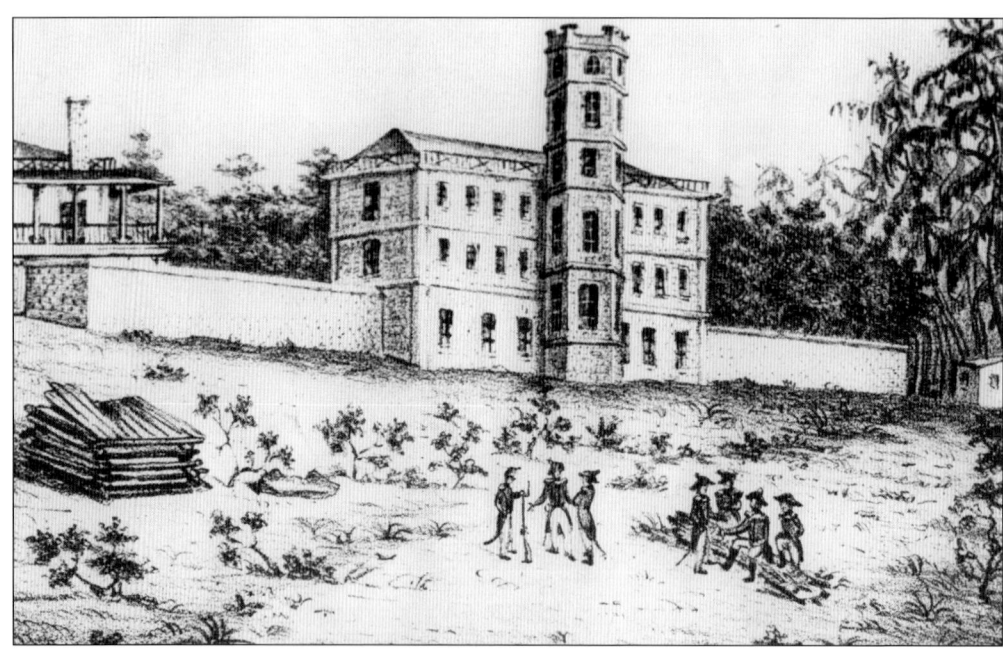

In 1832, Congress authorized the purchase of a military site on the Apalachicola River near the junction of the Flint and Chattahoochee Rivers. Construction of an arsenal began in 1834 and was completed five years later. A brick wall 12 feet high and 30 inches thick surrounded the building complex. In 1839, French explorer Comte de Castelnau sketched the newly built arsenal, showing Federal soldiers congregating outside the fort walls among the remnants of an old Indian village. (GCHS.)

A 1795 treaty between the United States and Spain established the 31st parallel, north latitude, as the boundary between the two countries. A boundary commission representing both nations was established to locate and mark this line. Pres. George Washington appointed Maj. Andrew Ellicott chief surveyor for the United States. Ellicott surveyed a line from the Mississippi River to the Atlantic Ocean, and began marking every mile with a four-foot-high mound. In 1799, Ellicott selected a site near the mouth of the Flint River, present-day Chattahoochee, as an observatory for his calculations. The line would eventually become the Alabama-Georgia-Florida state border. (SAF/FM.)

Among Gadsden County's earliest pioneers, Maj. Jesse Coe arrived in the late 1820s. Born in Maryland, he entered the Methodist ministry at the age of 18 and served under Andrew Jackson during the First Seminole War. A widower, Coe came to the Florida frontier to start a new life, purchasing the Aspalaga ferry and Rocky Comfort Plantation from the Croom brothers in the 1830s. By 1840, he had amassed a 4,500-acre plantation, including a 1,000-acre reservation purchased from Chief Yellow Hair. Prominent in church and Masonic Circles, he served as grand master of the Grand Lodge of Florida during 1834–35 and from 1840 to 1847. On June 25, 1845, Coe gave the invocation at the ceremony inaugurating Florida's new governor and statehood. (Courtesy of the authors.)

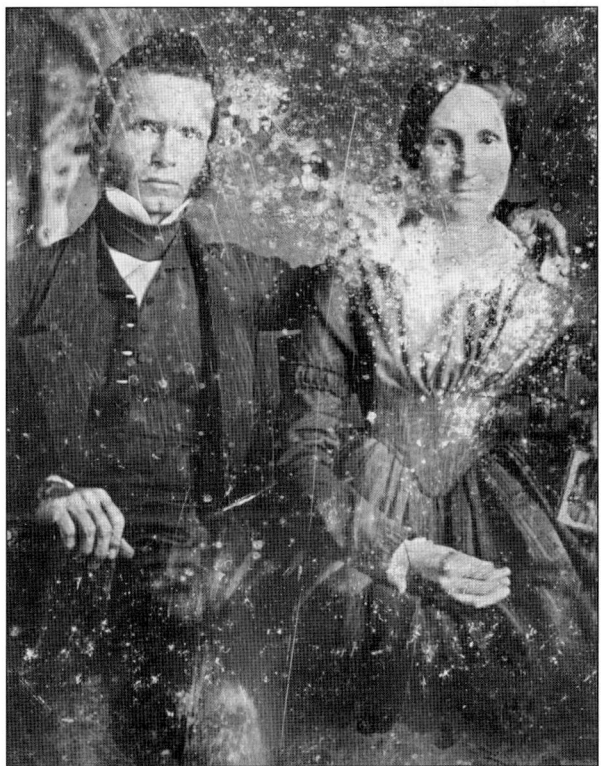

Charles Henry Dupont and his wife, Mary Ann, were among the pioneers arriving in Gadsden in the late 1820s. Born in Beaufort District, South Carolina, Charles Dupont graduated in 1826 from Franklin College in Athens, Georgia, before settling at Sweet Home Plantation. A lawyer, he began a consuming career in Florida politics. Territorial Gov. William Duval actively supported Dupont, appointing him to state banking positions and making him a Gadsden County judge. He was elected to the territorial senate in 1838 and became a member of the 1848 Electoral College. Dupont served as a Florida Supreme Court justice from 1854 to 1868, serving as chief justice from 1860 to 1868. Following the Civil War, he advocated immigration to Florida, seeking sources of inexpensive farm labor, until his death in 1877. (SAF/FM.)

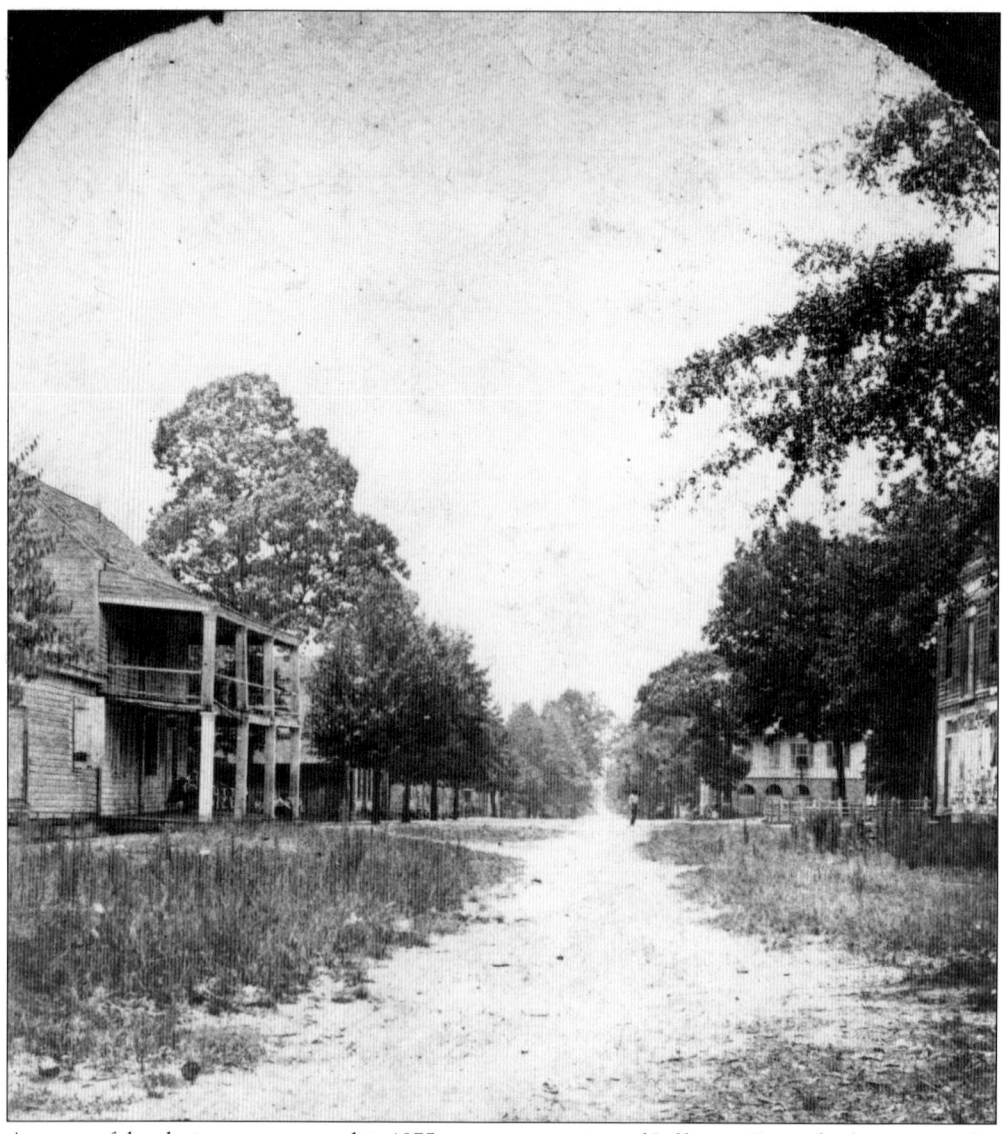

A sense of desolation permeates this 1875 stereoscope view of Jefferson Street looking west, the earliest known photograph of Quincy in the decades following the Civil War. A ramshackle building, John C. Gunn's former general store, stands to the left, while idle men lounge beneath the decrepit piazza. At right, among the weeds on the corner of Madison and Jefferson Streets, molders Joe Davidson's drugstore. A solitary figure pauses at the south side of the hidden courthouse. Inside the square's southwest corner, just beyond the circular wood fence, stands the open brick arcade of the 1850 Market Hall. (GCHS.)

Two
Sense of Place

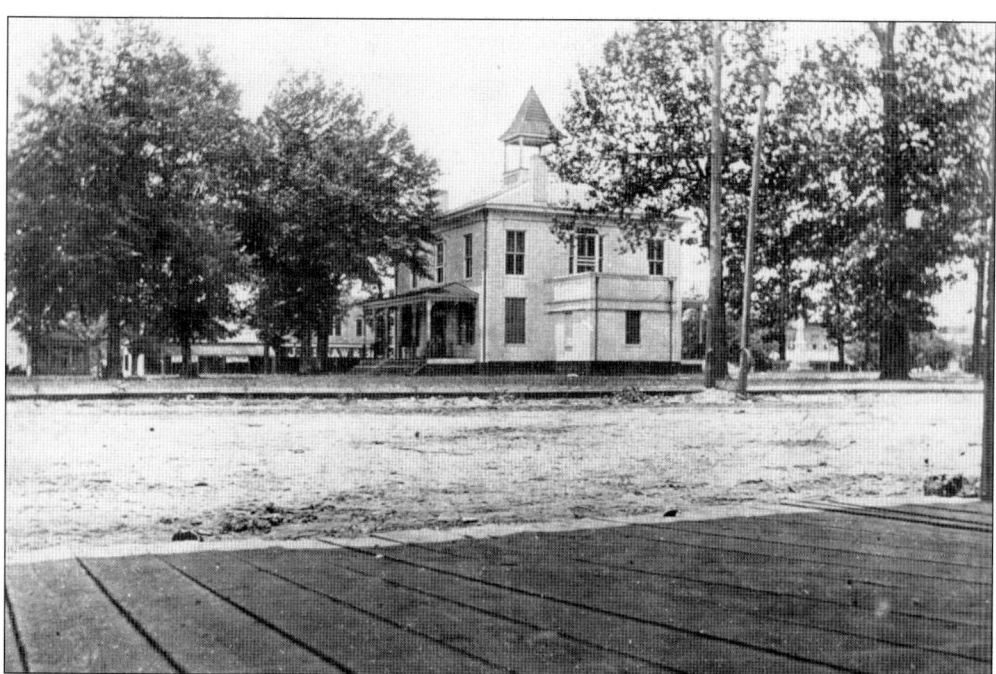

An old-timer once wrote of the 1850 Gadsden County Courthouse, "If this old building could have told its life history, there would have been many a strange story . . . the Wild West would have to move way over." The wooden boardwalks in this 1903 photograph embellish these comments. This foursquare building featured identical north and south entrances and flanking fireproofed wings. It was demolished in 1912 and replaced by the current Neoclassical structure. (GCHS.)

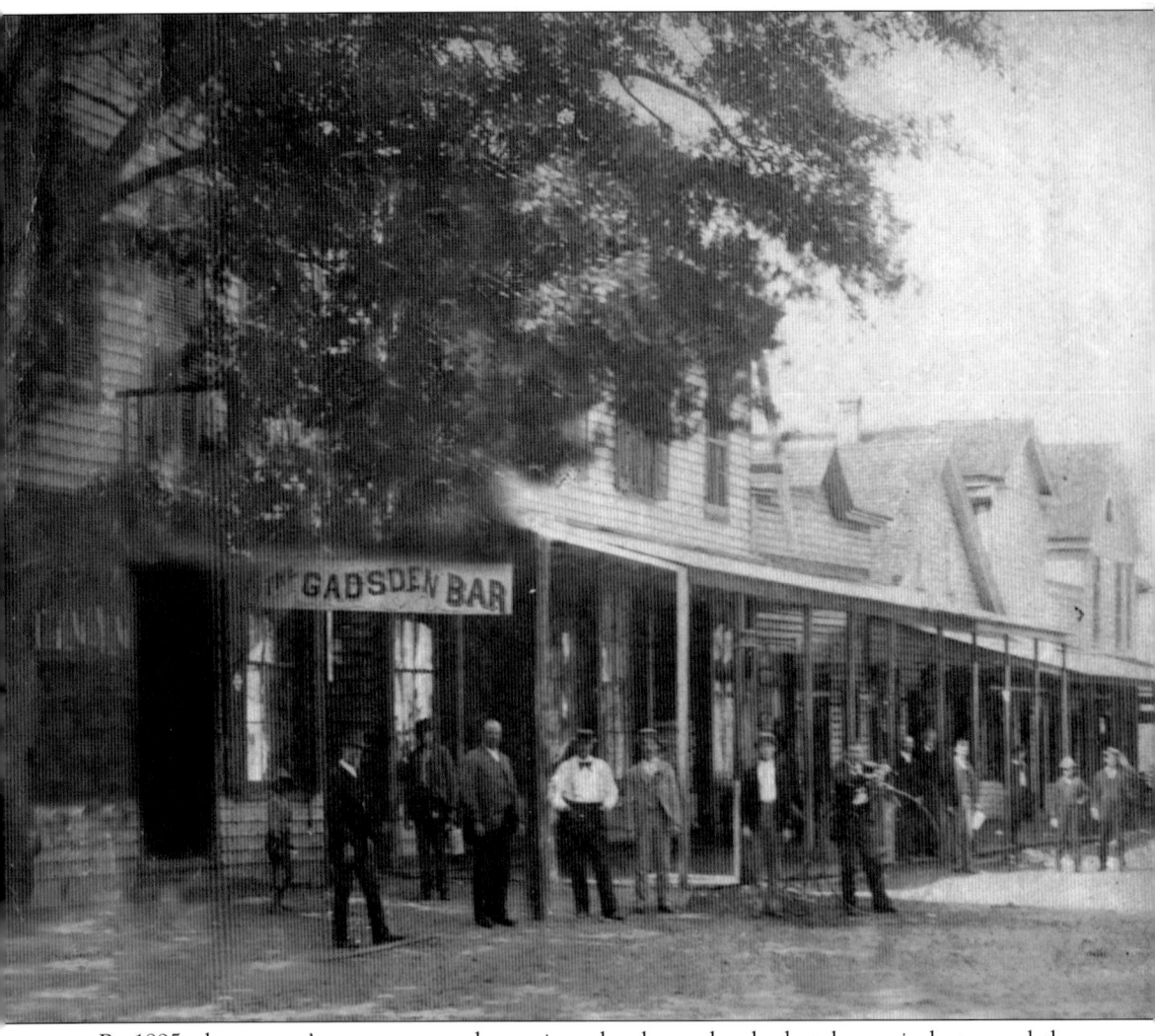

By 1895, the county's economy was humming, thanks to the shade tobacco industry and the discovery of Fuller's earth. The transformation was dramatic. One travel writer gushed over Quincy's "densely crowded sidewalks on Saturday nights," making it "possibly the most lively, wide-awake town in Florida." This photograph shows the south side of Jefferson Street. Nicknamed "Rotten

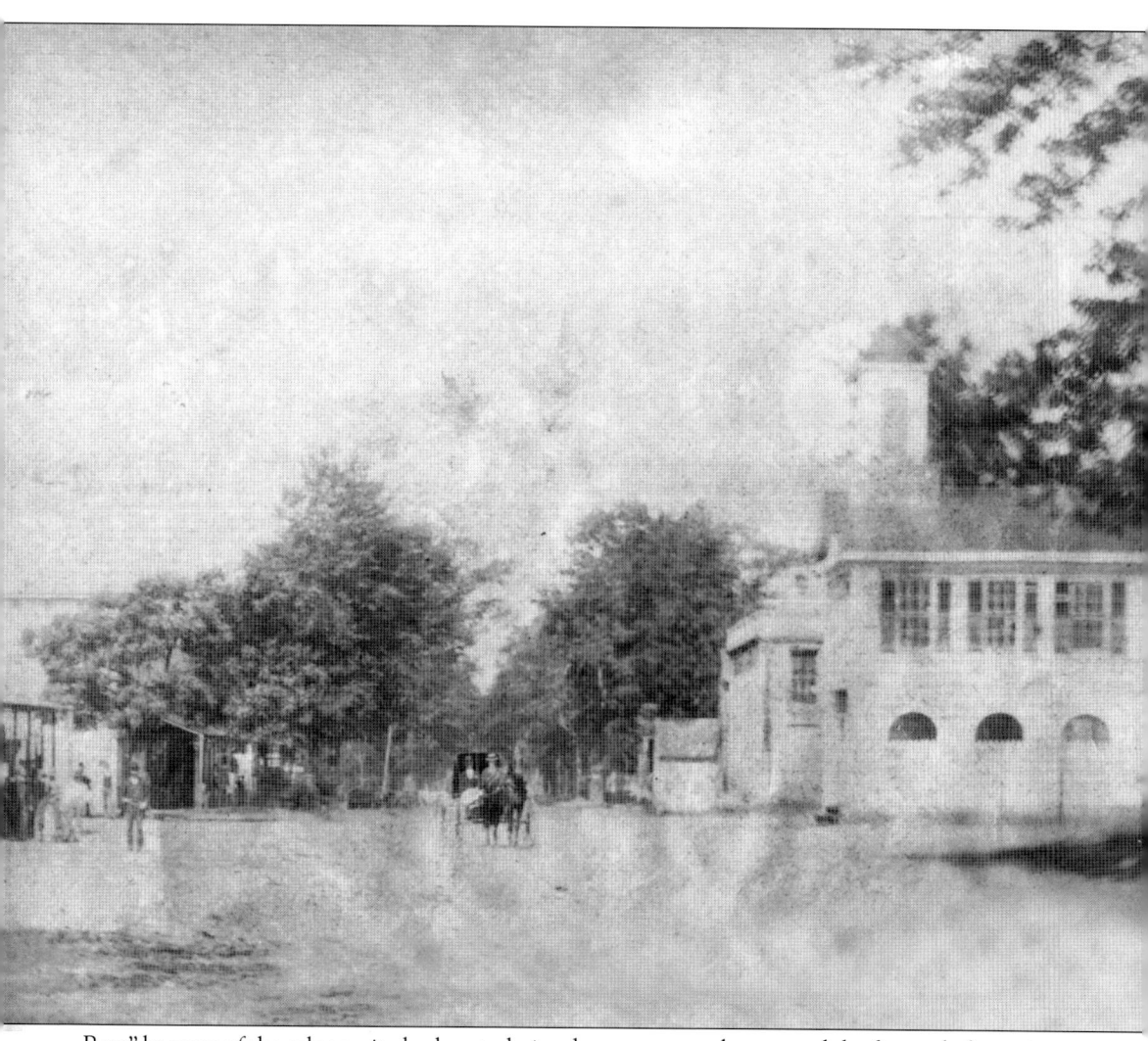

Row" because of the saloons, it also boasted nice shops, an opera house, and the first soda fountain. At the right stands the antebellum Market Hall, where county farmers wishing to sell their fresh meats would ring its belfry bell to attract buyers from all over town. (GCHS.)

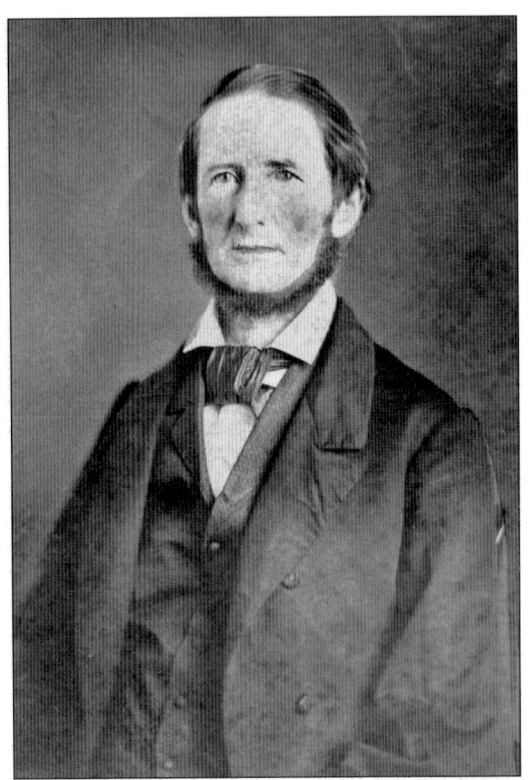

Early merchant Isaac Ross Harris was a wealthy tobacco planter, politician, sheriff, county judge, and Quincy's first mayor. In an 1859 Quincy newspaper, I.R. Harris & Company advertised wool, beeswax, eggs, cured hides, Georgia flour, sugar, hams and bacon, mess pork, liquors, porter, and ale. After a long, prosperous career, Harris died at Quincy in 1887. (Courtesy of the authors.)

Aaron Byrd Preston became Quincy's first African American store manager when working for the R.C. Stearns' General Store in 1891. A former schoolmaster, Preston was the store's buyer and salesman, taking charge during his employer's absence. Preston managed the store, located on Jefferson Street's "Rotten Row," for 13 years. He also owned his own bar and soda fountain. (GCHS.)

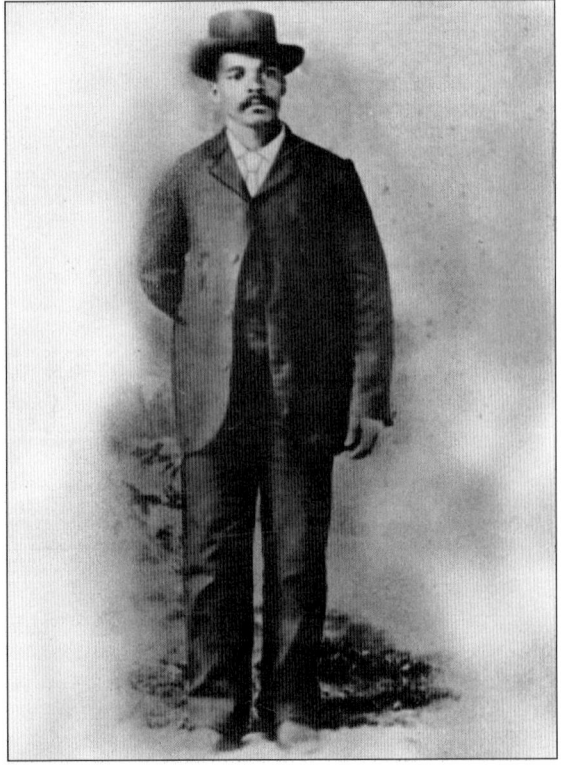

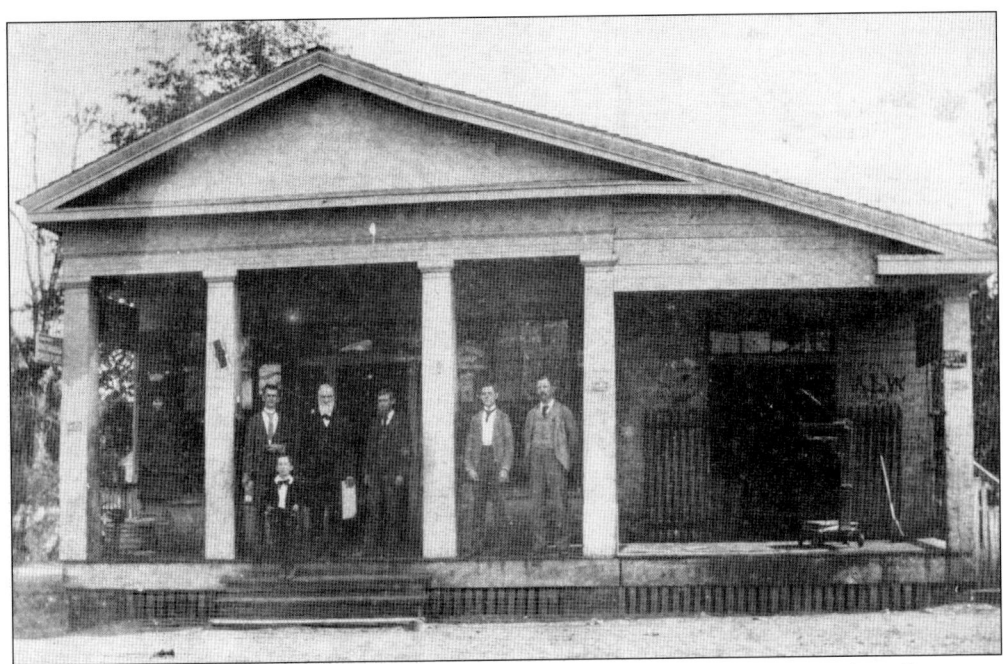

Standing among the columns of an antebellum building is the staff of the A.L. Wilson Company, Quincy's oldest department store. Photographed in 1890, this business was located at the southwest corner of Jefferson and Monroe Streets. The 1858 Greek Revival structure built by Isaac Jeffries for Dr. Charles Hentz was typical of the style of building that professional lawyers and doctors preferred. The extension to the right was added by the store. (GCHS.)

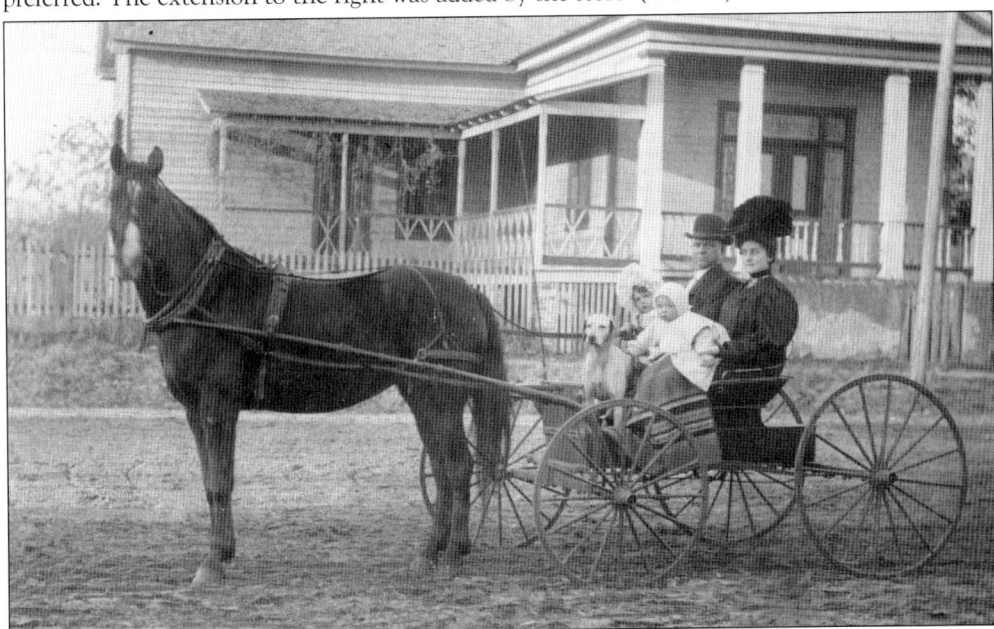

Out for a buggy ride, the R.M. Davidson family pose in front of the Greek Revival law office of Judge Charles H. Dupont. Constructed on Jefferson Street, this antebellum building stood opposite the medical office of Dr. Hentz. In later years, the structure housed a variety of businesses, including a Chinese laundry, before being removed in the 1970s. (Courtesy of the authors.)

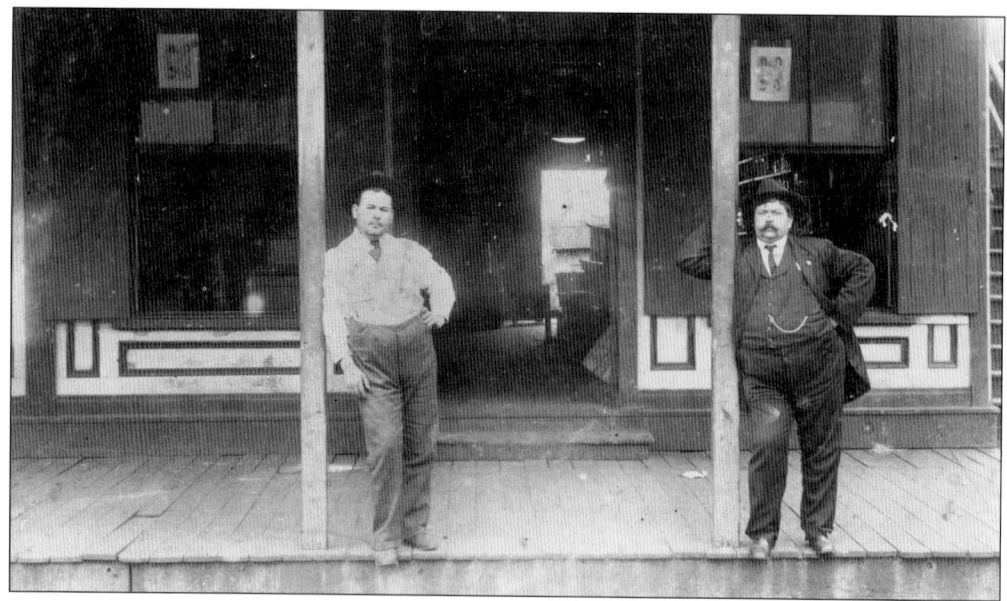

Looking like characters from a Wild West movie, brothers Max (left) and "Boots" Munroe lean against the posts of their Jefferson Street grocery store in the above photograph from around 1900. The scene invokes Dodge City, with a boardwalk and old-fashioned casement windows flanked by shutters locked each night. "Boots," nicknamed for a boyhood love of the footwear, seems to have stepped out of central casting: handlebar mustache drooping beneath a slouched hat, watch chain suspended across a wide girth, and hand on hip revealing a deputy's badge. By 1907, the Munroe brothers were doing well enough to relocate to the Gee Building on Jefferson Street facing the Gadsden County Courthouse (below) Pictured in 1909 from left to right are Elox Onell, William "Boots" Munroe, Mr. Palmer, Judge P.S. Thomson, and Max Munroe. (Courtesy of the authors.)

Bartender Ed Hargrave (right) and "swamper" Brinkley, shown here sometime before 1907, posture before the swinging doors of the R.H. Gee Saloon on Jefferson Street's "Rotten Row" south of the courthouse square. The saloon sold beer and the house brand, "Dick's '76," which advertised itself as "Pure Old Whiskey Distilled and Bottled Expressly For Family Use" by "R.H. Gee, Quincy, Florida." Unfortunately, family use would soon be prohibited due to Gadsden's countywide ban on liquor sales, which lasted most of the 20th century. (Courtesy of the authors.)

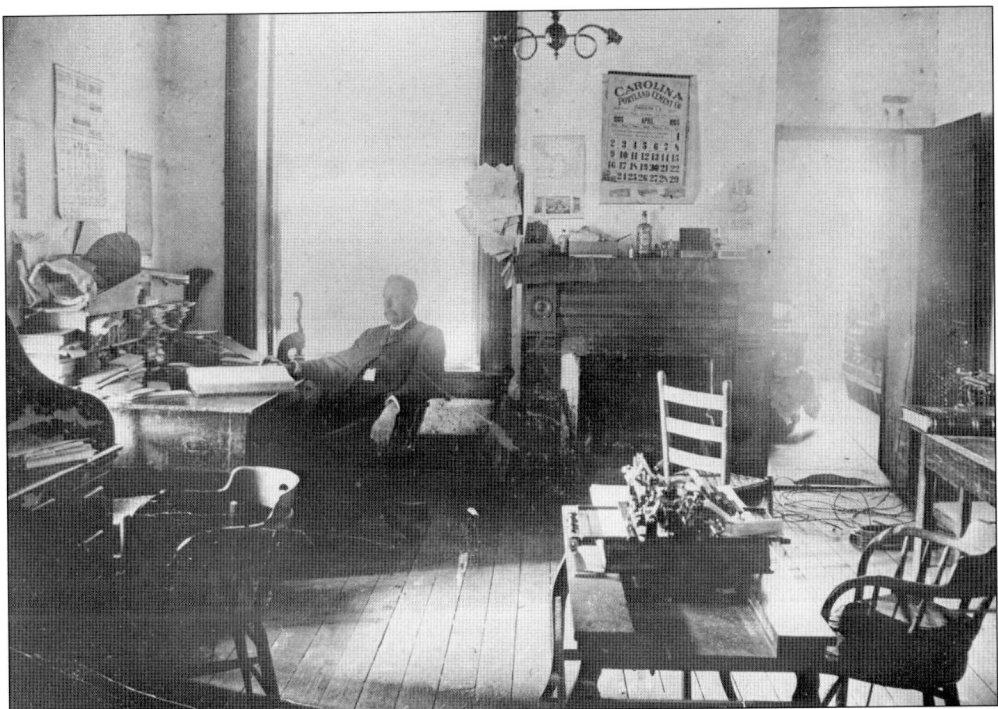

Photographed in 1905, Thomas Mitchell, Gadsden County clerk of the courts, lounges in his chair next to the county seal, his badge of office. Through an open doorway can be seen the fireproofed east record room. Not surprisingly, among the assorted documents, ledgers, and mismatched furniture sit a whiskey bottle, shot glass, and cigar box, waiting for the day's end. A former sheriff and mayor, Mitchell served as clerk for 13 years, ending his tenure in 1907. (SAF/FM.)

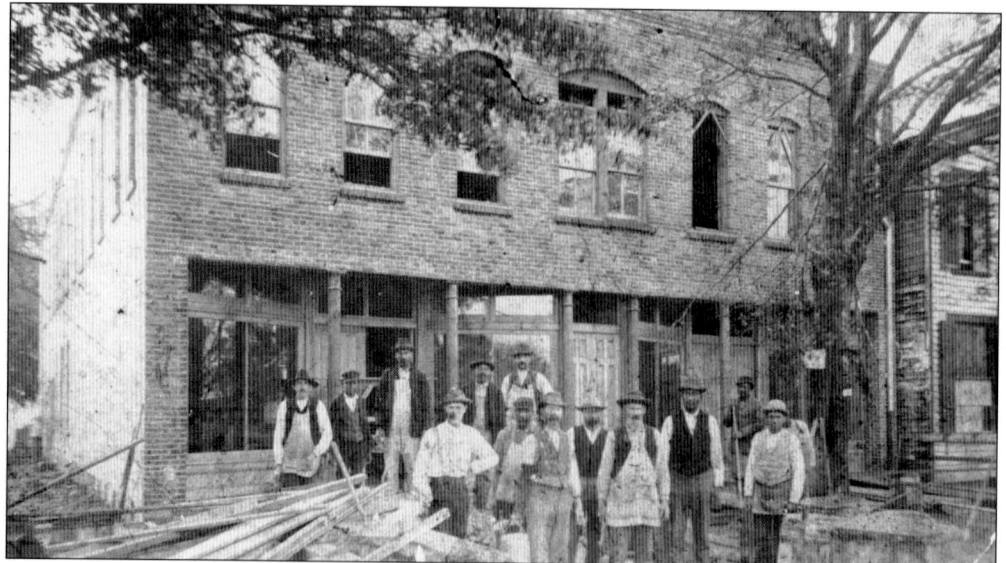

In the spring of 1896, assembled workers near completion of the first brick building on Jefferson Street's "Rotten Row." For years, this block was comprised of a ramshackle assortment of wood buildings, some of which would be condemned with the creation of Quincy's new fire department in 1897. The new Love and Hearin Building above symbolized the economic success Gadsden County was enjoying on the eve of the 20th century. By 1907, the entire block would be replaced with new buildings of fired-brick construction. (GCHS.)

The county's robust economy brought an increased demand for buggies and wagons, and the A.L. Wilson Company store shown here filled that demand. Soon, however, the automobile arrived, and Wilson's relegated its wagon inventory to a smaller warehouse. Beatty Gossett (left) and David Avant pose in an office surrounded by farm supplies. (SAF/FM.)

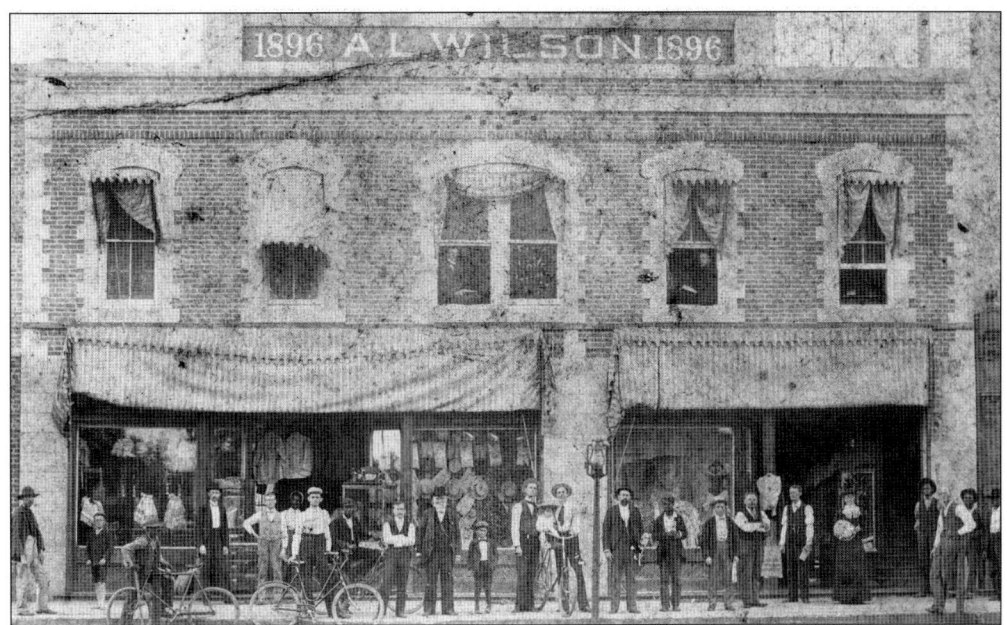

In the 1890s, in the wake of Gadsden County's economic boom, a plethora of general mercantile stores sprang up. Foremost was the A.L. Wilson Company's 1896 facility on Washington Street. "Wilson's on the Square," the slogan familiar to generations, began here. In this 1898 photograph, the display windows are alive with bric-a-brac, furniture, straw boaters, and dresses. Outside stands a cross-section of the community. By the end of 1898, the kerosene lampposts were replaced with electric street lights, another sign of growing progress. (GCHS.)

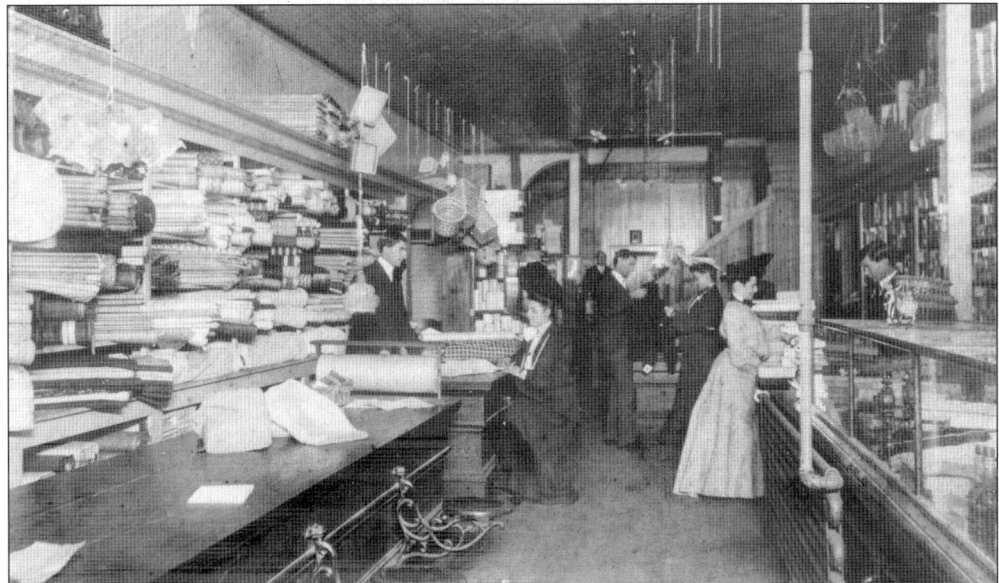

Most Gadsden merchants offered a variety of goods, as did the A.L. Wilson Company at its location north of the courthouse. The store offered a diversified inventory, including the bolts of fabric that housewives sought for clothing and home projects. In the age of the treadle sewing machine, May Davis Cobey, seated on a stool, examines the selections being offered by sales clerk C.C. Guy. (GCHS.)

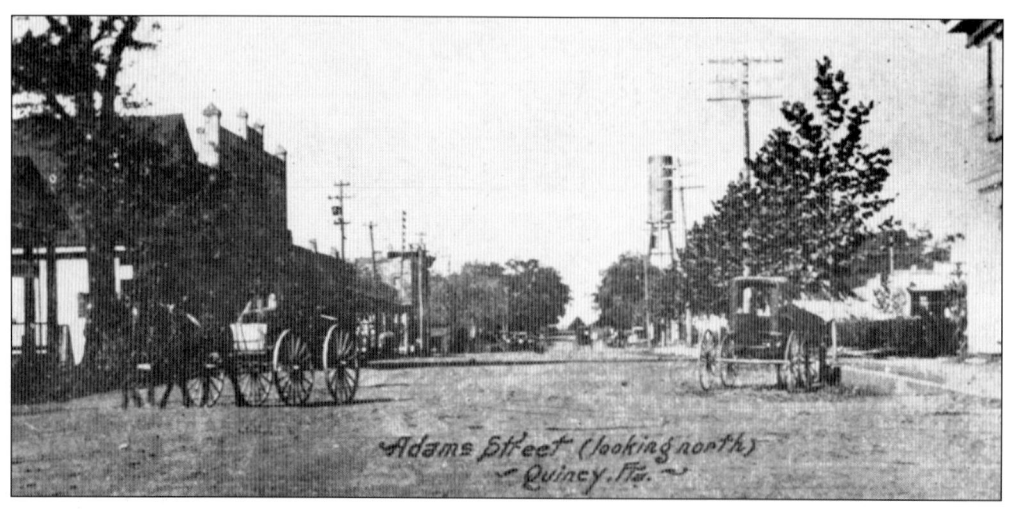

Both of these postcards show Adams Street looking north. The above view, from 1903, shows the antebellum medical office of Dr. Thomas Munroe at the far left. Next to this Greek Revival structure is a front-gabled wood store built in the 1890s. In the background stands a water tower, at the impressive height of 110 feet. By 1913, below, the west side of the square was filling in. The First National Bank and the F.P. May Drug Company replaced the earlier wood store. "Home of Frank May's Digestive Tonic," the drugstore was the culmination of May's successful career, which began in 1876. Completed in 1910, the store was the final location of a business that lasted well over 100 years, among the oldest in Quincy. In the right background stands a 100-foot water standpipe holding almost two and a half times that of the previous water tower. (Above, courtesy of Richard May; below, courtesy of the authors.)

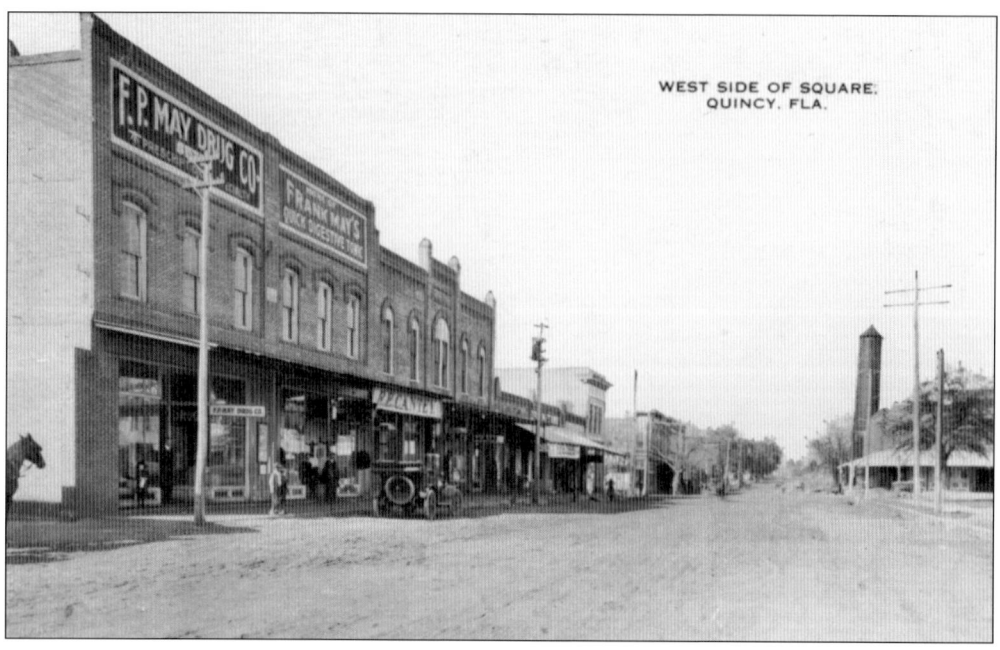

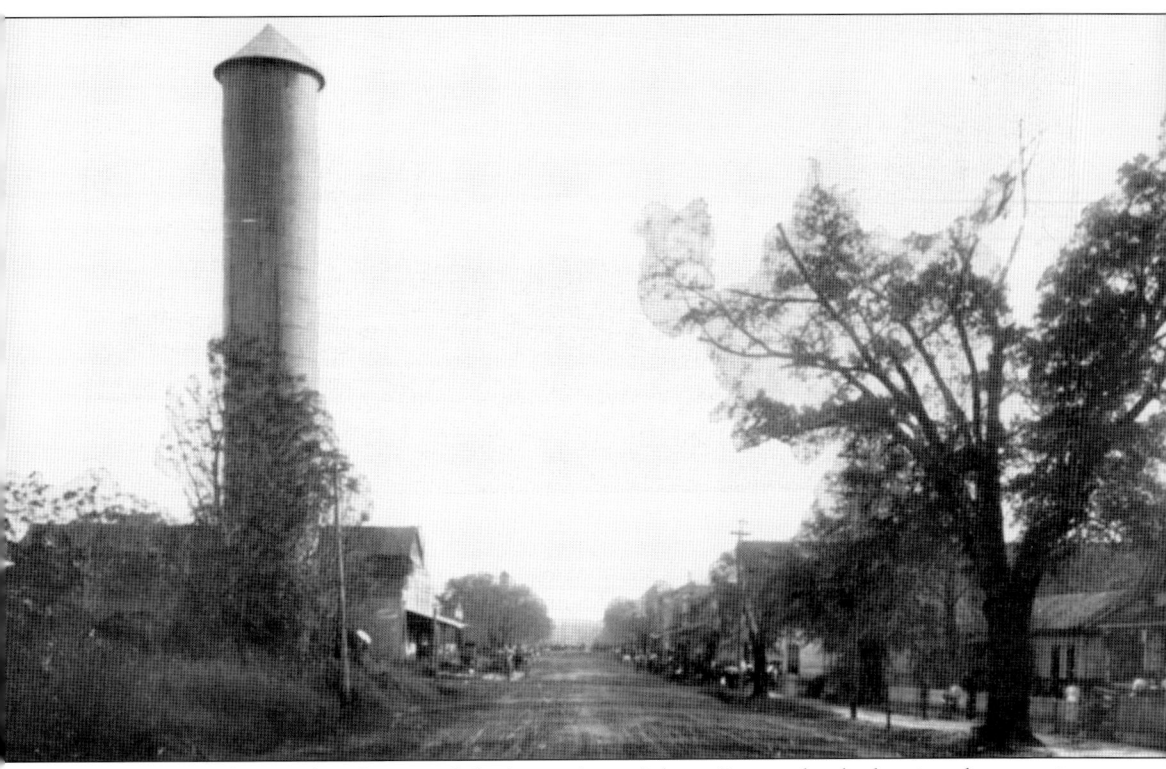

Taken around 1913, this photograph looks south on Adams Street, clearly showing the new city water tower, constructed at the northeast corner of Adams and Franklin Streets. Standing 100 feet high, this standpipe had a capacity of 168,000 gallons. Across Adams Street can be seen a one-story Folk Victorian house, now the headquarters of the Gadsden County Chamber of Commerce. (Courtesy of the authors.)

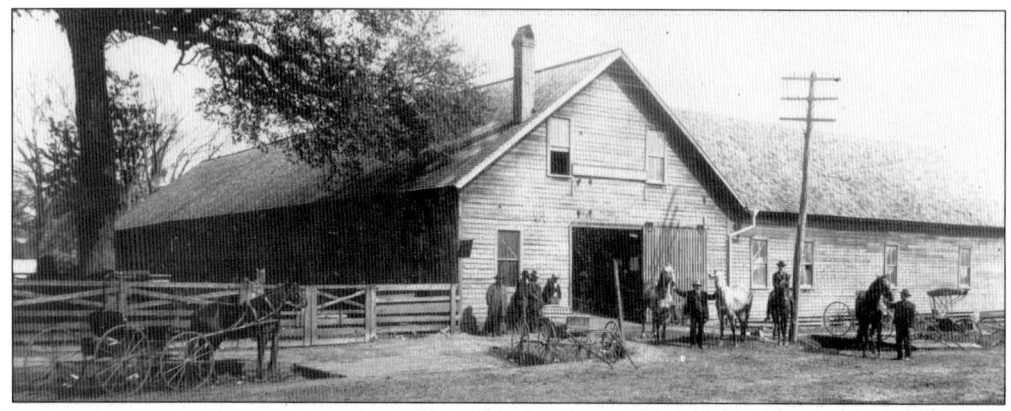

As the horse-and-buggy era dimmed, stables abounded in Quincy, including Henderson's Buggy Company (above) and Howks' Sale Stable (below). Customers either rented or purchased horses, mules, and buggies from these establishments, and professionals were dependent upon them. Located near the northwest corner of Washington and Duval Streets was Henderson's, which sold wagons and horses and functioned as a livery and carriage house. By the 1920s, it was used to store automobiles for a local dealership. Howks' Sale Stable was removed sometime before 1907. (Courtesy of the authors.)

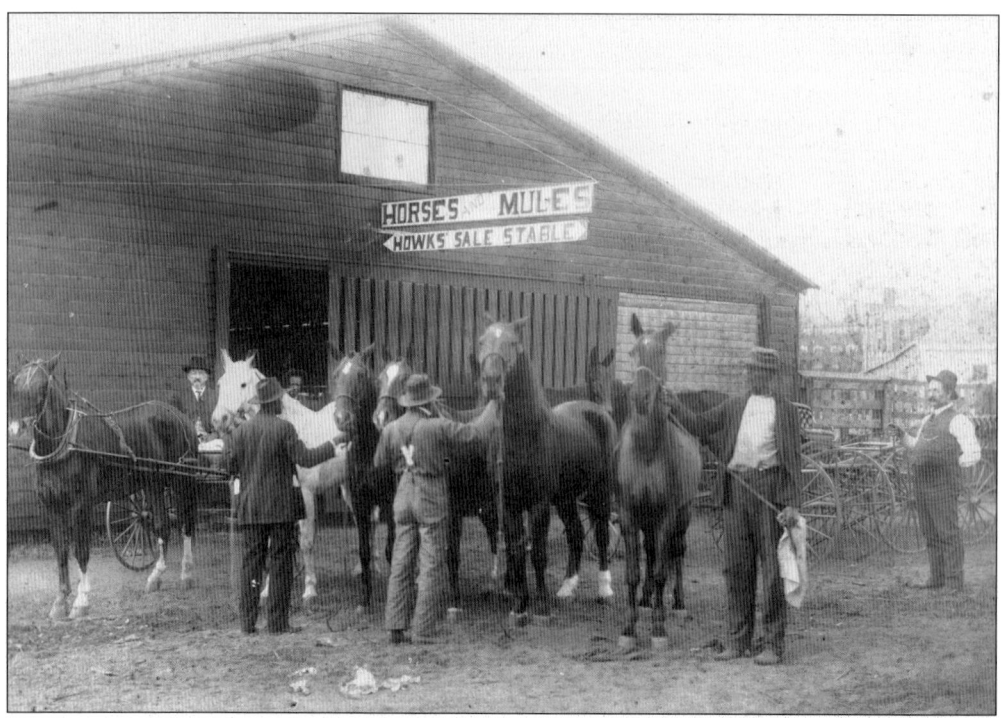

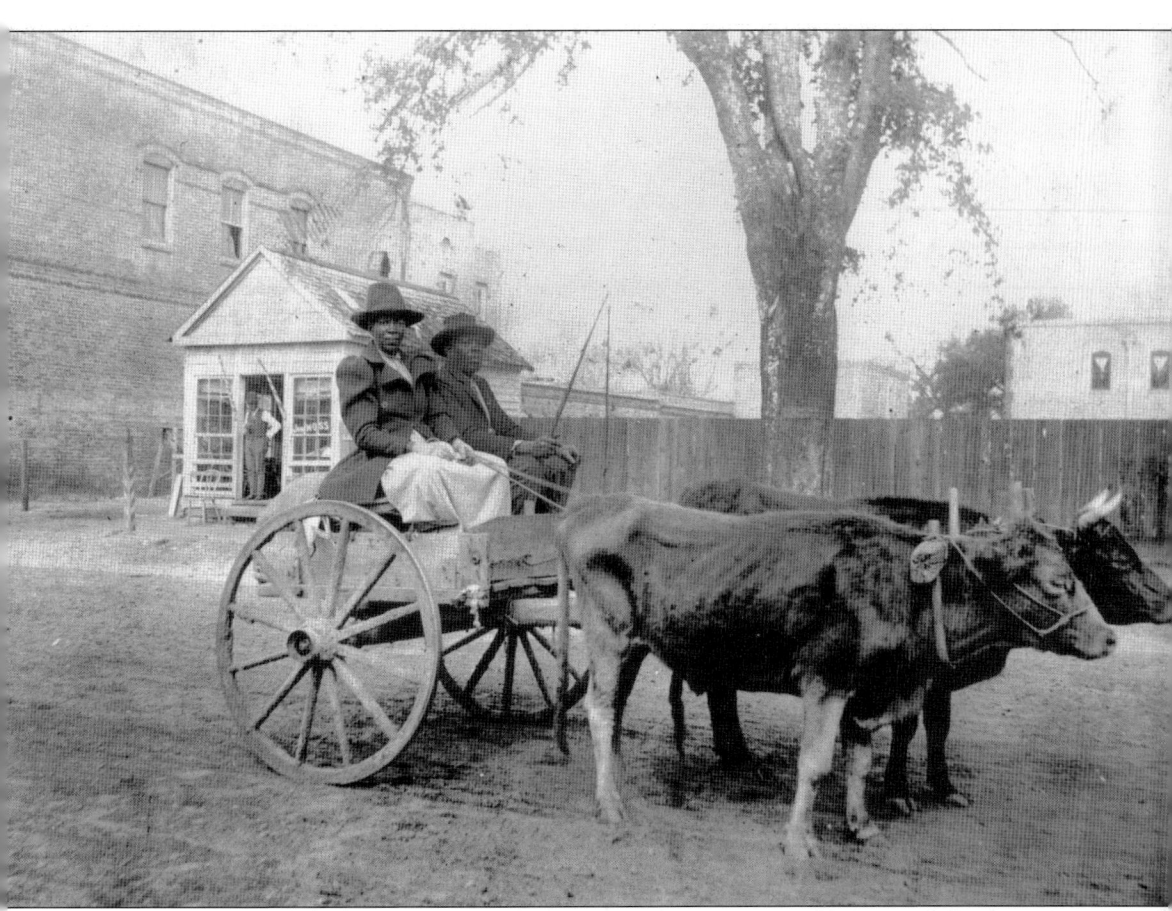

African American John Moss was a popular barber in the community during the difficult years of Reconstruction. Concerned with education, Moss served on the Gadsden County Board of Public Instruction in 1877 and 1879. In 1880, he was a trustee of Quincy No. 2 Public School, responsible for educating 140 African Americans. John and his wife, Lillian, attended the Episcopal Church. His small string band, featuring his family, played for most of Quincy's dances. But his primary livelihood was barbering, and from this location on the north side of Jefferson Street just east of the courthouse square he conducted business. Photographed around 1900, Moss stands at the entrance of his shop between two angled barber poles; another is positioned vertically out front. In the foreground, an African American couple, the photographer's obvious interest, pause in their ox cart. (GCHS.)

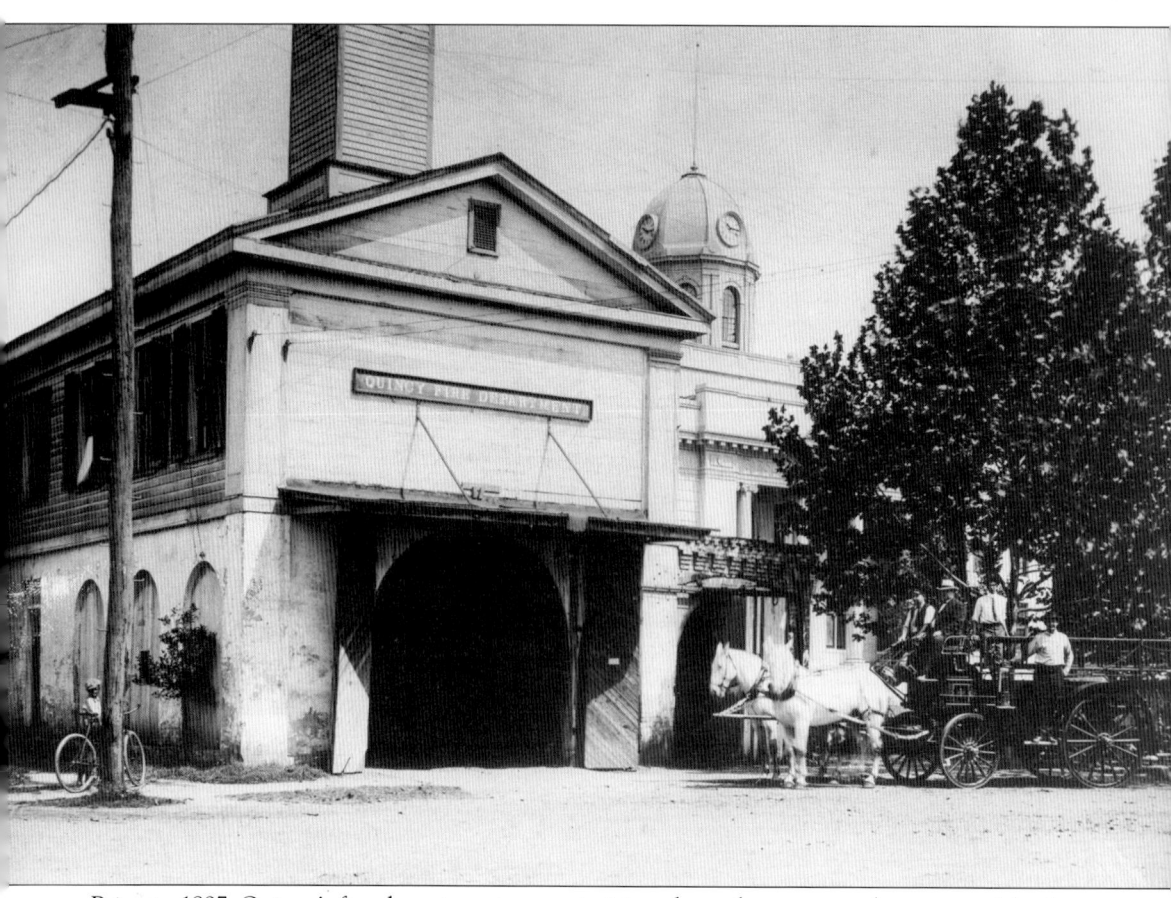

Prior to 1897, Quincy's fire department was primitive, dependent upon volunteers and bucket brigades. Bells pealing throughout town alerted citizens. The thriving 1890s economy demanded modern firefighting capabilities, and, in 1897, a fire department was created. With new headquarters on the square, the antebellum Market Hall on the northeast corner of Jefferson and Adams Streets was converted into a firehouse to store the horses and hook-and-ladder wagon. The new 1913 courthouse and the old 1850 Market Hall are seen in this photograph. In December 1914, the fire department moved into a new facility shared with city hall on South Madison Street. The horses and fire wagon acquired in 1900 were then sold to the town of Marianna, Florida, following delivery of a new fire truck. (SAF/FM.)

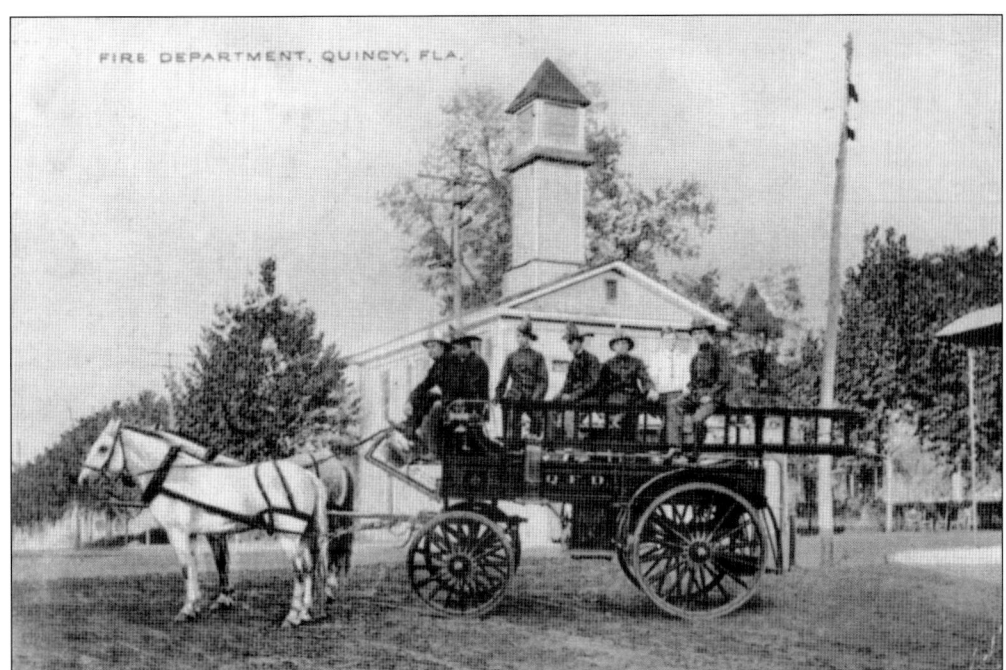

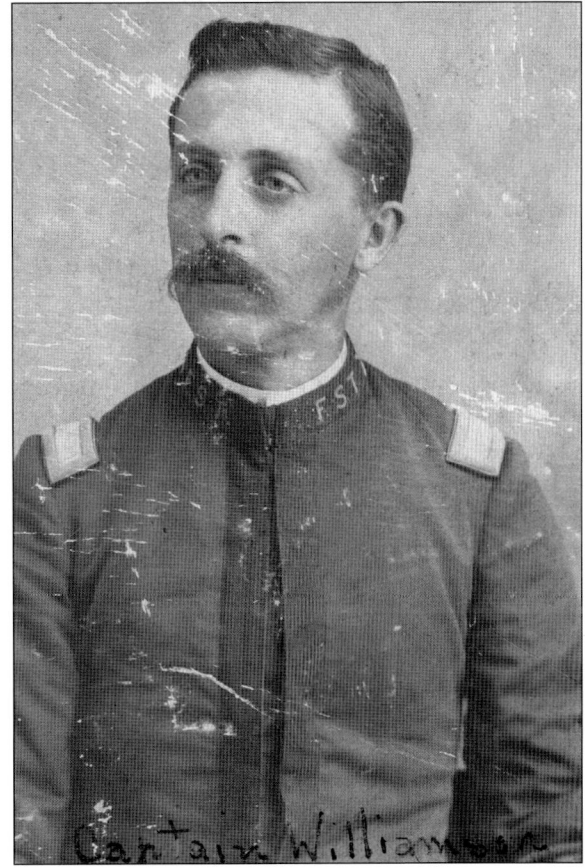

Pennsylvanian Samuel T. Williamson (right) became Quincy's first fire chief in September 1897 after Councilman William Corry proposed organizing a fire department. Elected by his fellow firefighters, Chief Williamson actively participated as both chief and city councilman until shortly before his death. Under his leadership, the department made impressive strides in fire safety, implementing the first citywide fire alarm system in 1898 and expanding the chief's role to include oversight as a building and wiring inspector. Perhaps his greatest honor was having one of two matched gray fire horses (above) named Sam. The other was named Herbert, after Quincy mayor Herbert Love. (GCHS.)

This rare view, from around 1918, looks east on Jefferson Street. The contrast between old and new is evident: the oxcart and buggy shares the road with an automobile, and the new 1913 courthouse dome peeks just over the antebellum store of Scotsman William Munroe. Behind the Munroe store stands the former Altschul tobacco warehouse. Across the square is the City Drugstore prior to its renovation into a one-story building. (SAF/FM.)

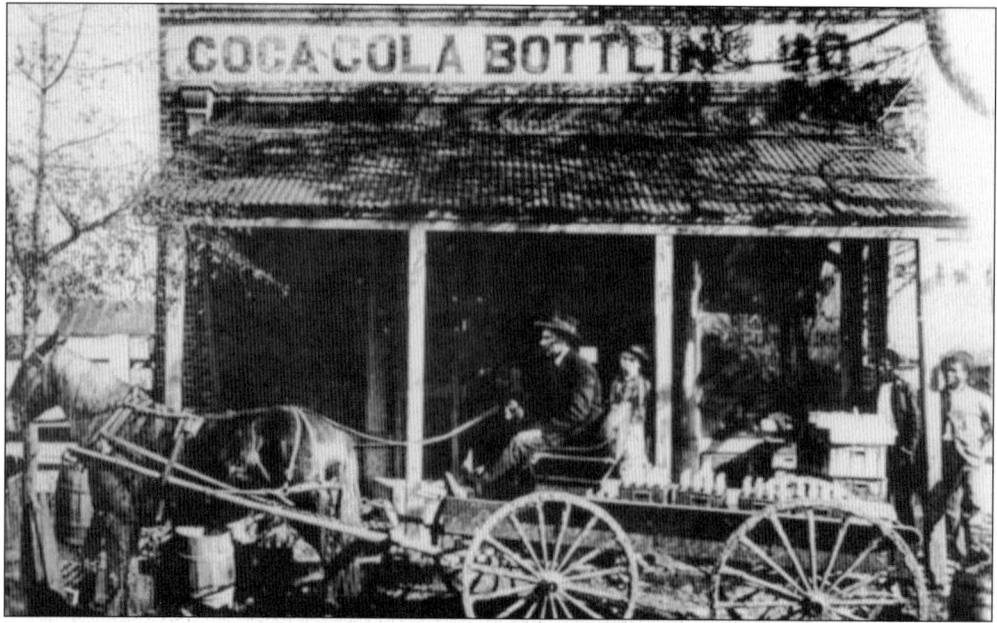

For a brief time, the original Quincy Coca-Cola Bottling Company operated on Adams Street, one half block north of the courthouse square. In 1907, the new brick building formerly housing a bakery became Quincy's first Coca-Cola franchise. Owner Robert I. Stephens is purported to be making his first delivery of the iconic drink in this 1908 photograph. Packed in his wagon are crates containing the straight-sided bottles Coca-Cola used between 1900 and 1915. (GCHS.)

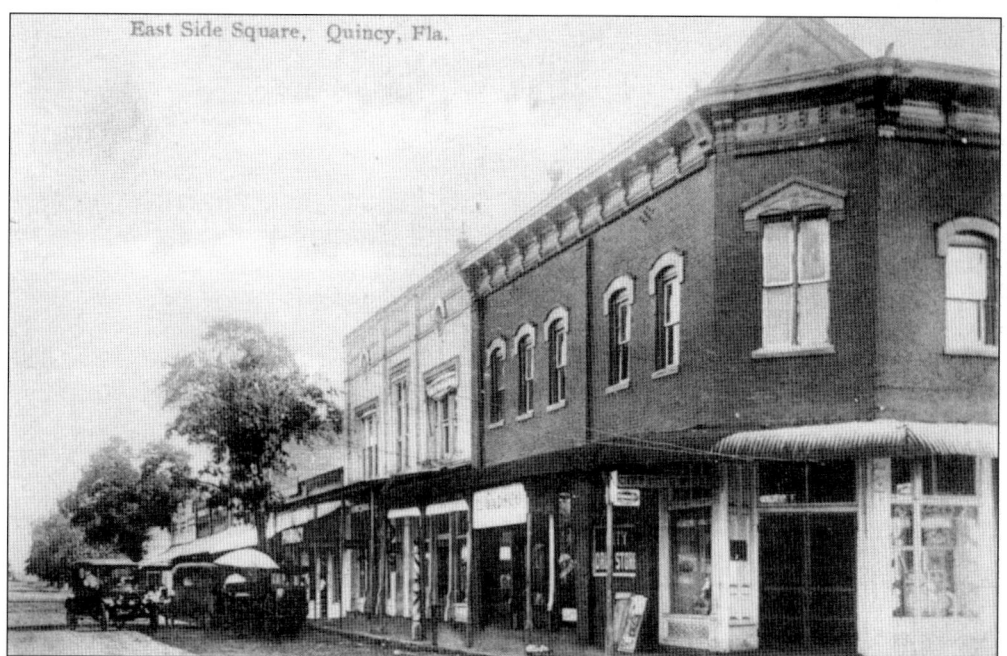

The Ward Building, built in 1888, anchored the northeast corner of Jefferson and Madison Streets. Once home to the City Drugstore, this structure is the oldest existing on Courthouse Square. To its north, housing a pharmacy, is the Harper Davidson Building, built before 1903, and, just beyond, obscured by a tree, is the 1912 headquarters of Bell & Bates Hardware. Before 1922, the brick-veneered second story was removed, reducing the Ward Building's height to one story. (Courtesy of the authors.)

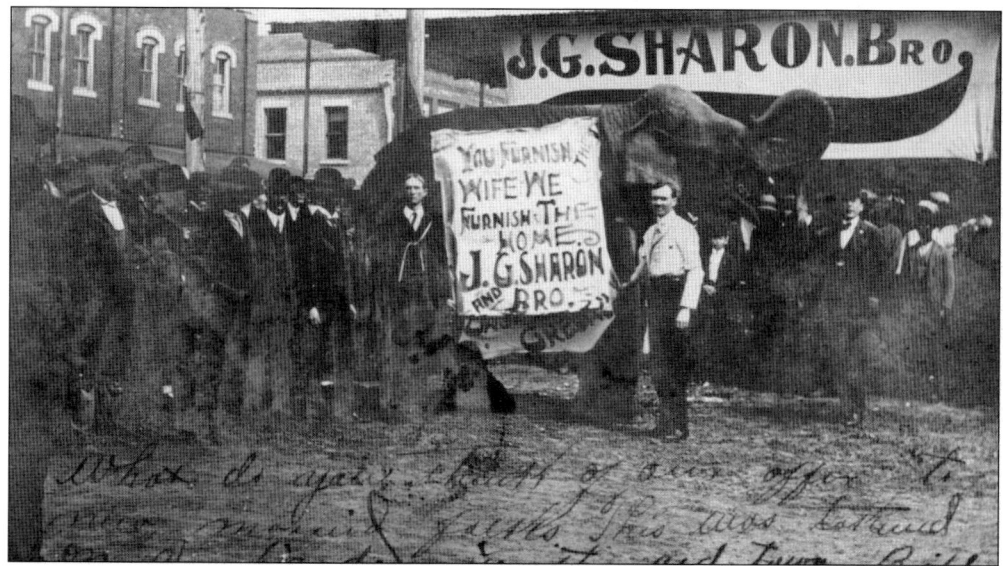

By the looks of the crowd, parading an elephant through downtown Quincy was an effective form of advertising in the early 1900s. "You furnish the wife, we furnish the home" was the clever slogan of J.G. Sharon Brothers Company. Located opposite the City Drugstore, on the southeast corner of Jefferson and Madison Streets, Sharon Brothers sold "Gent's Clothing," boots, and shoes. (Courtesy of the Claire Munroe Bates Family.)

The county's growth spurred a profusion of services, with local merchants catering to citizens and an influx of tobacco buyers negotiating business deals. Within a block of the 1913 courthouse were a quality hotel and restaurant, a movie theater, three boarding houses, six druggists, two jewelers, and five competitive barbershops. Strategically located in the Sharon Building on the south side of Jefferson Street was African American Nathan Hadley's establishment. Being across from the Hotel Quincy and adjacent to a boardinghouse, Nat Hadley was well positioned to serve any businessman requiring a haircut and shave. (SAF/FM.)

With the cultivation of shade-grown tobacco, the Owl Commercial Company in 1887 hired African American veterinarian William Hardon to purchase horses and mules for the company's interests. During the summer of 1898, Hardon (shown here) signed a contract agreeing to supply Quincy with 20 electric street lamps, lit from twilight to dawn, at a cost of $1,000 per year. His original steam-powered dynamo was housed in a new electric plant on Washington Street. Hardon also constructed an ice plant and saloon, where dice and cards were played in the basement. (GCHS.)

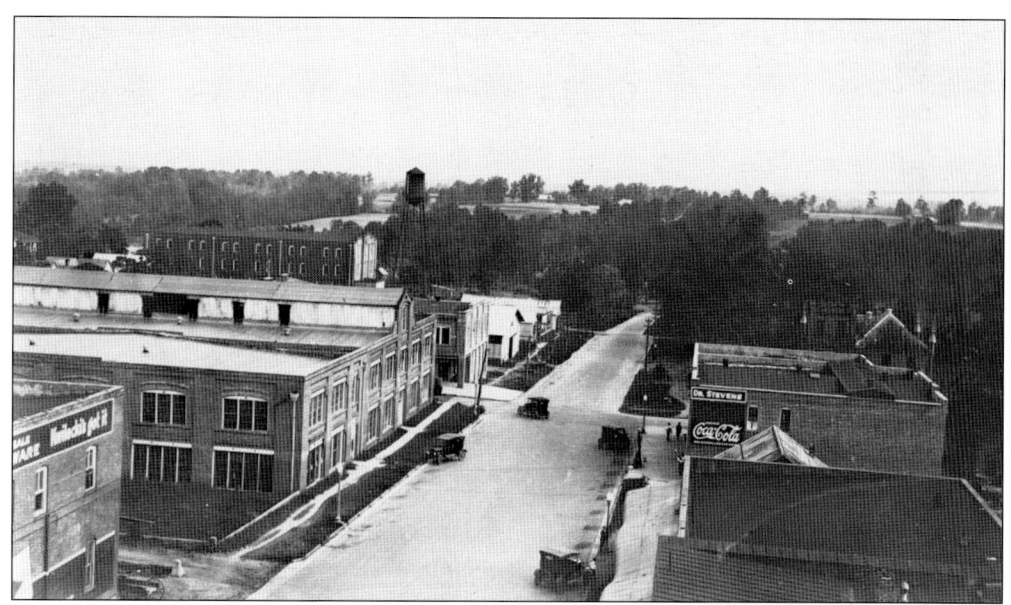

Upon graduation from Meharry Medical College, class of 1904, Dr. William Spencer Stevens returned to Florida, becoming the first African American doctor in Gadsden County. Later, he purchased a lot on the northwest corner of Adams and Crawford Streets across from the old jailhouse (above) and opened the Dr. Stevens Drug Store, an adjunct to his practice and his work in Stevens Hospital. In addition to selling pharmaceuticals, the new establishment served as a social setting, complete with bistro seating and soda fountain. In the photograph below, Dr. Stevens (left) is seen with pharmacist Dr. Aaron Goodwin, a future dentist. Stevens was an outstanding leader in the African American community. (SAF/FM.)

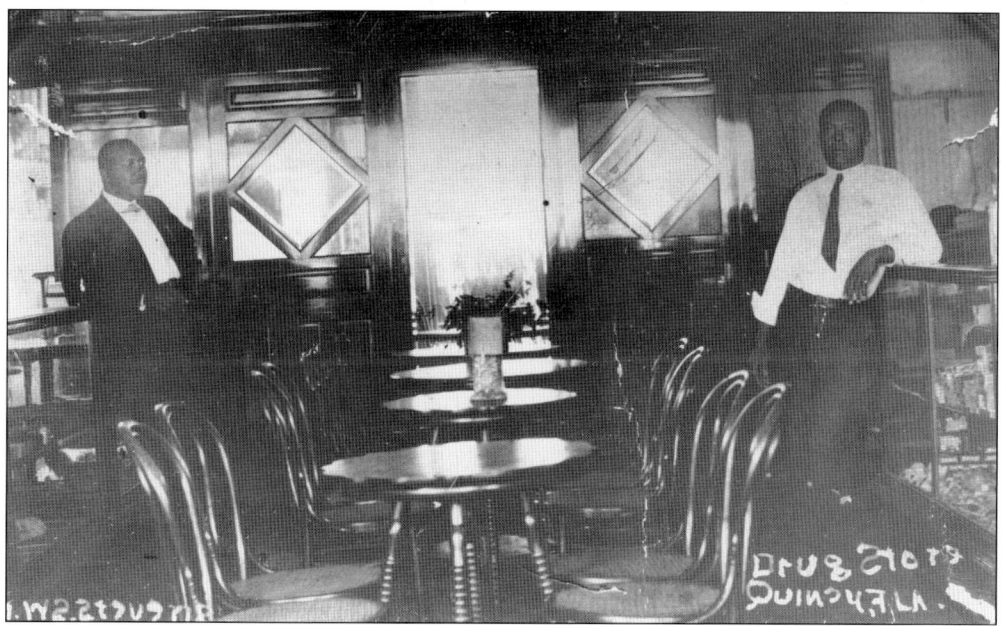

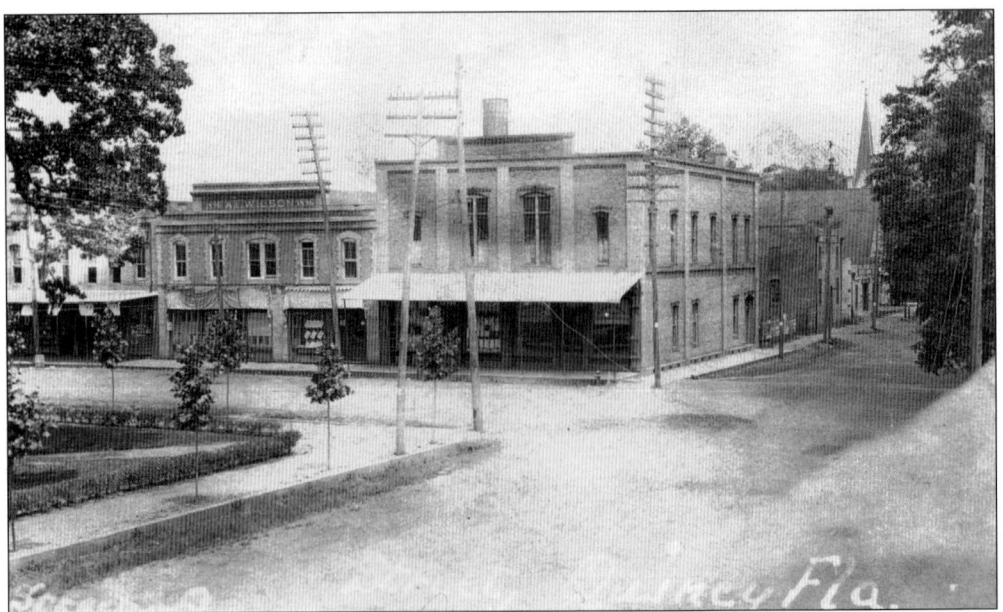

For decades following a devastating fire in 1867, the north side of the square remained devoid of any buildings. Finally, in 1893, the Quincy State Bank Building was completed on the northwest corner of Washington and Madison Streets. This new facility contained banking offices on the first floor and an opera house on the second. (Courtesy of the authors.)

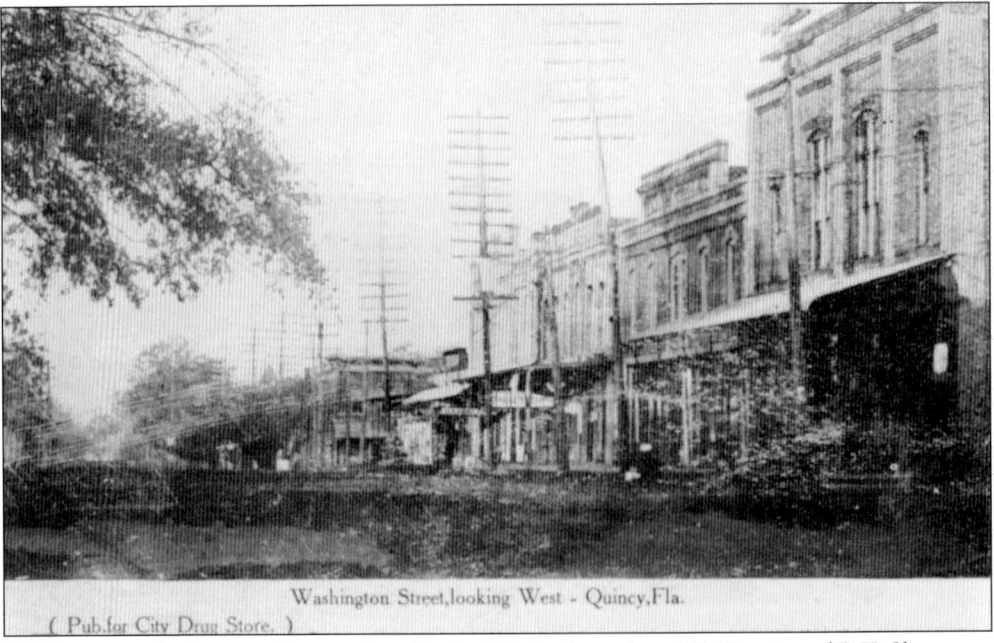

The first two telephones in Quincy, installed in 1898, belonged to A.T. Hearin and R.K. Shaw, two men with businesses located on opposite sides of the square. Deciding that two-way communication would save both time and money, they acquired the necessary equipment and installed the lines themselves. Soon, more lines were added, a switchboard was purchased, and a daytime operator was hired. The first telephone company office was located on the north side of the courthouse square, next to the A.L. Wilson Store. (Courtesy of the authors.)

Mark W. "Mr. Pat" Munroe (right) served as the president of Quincy State Bank for almost 50 years. The bank, established in 1889, was Florida's first chartered bank. It deposited $1 million in 1919, the same year Coca-Cola stock went public. It was Munroe's friendship with Coca-Cola's first chairman, W.C. Bradley, that began the long association between county, bank, and iconic drink. Mr. Pat thought most people would always have a nickel to buy a Coke. After Mr. Pat's death in 1940, the *Gadsden County Times* printed what would become his tombstone epitaph: "The influence of his personality was so great, and his advice so widely sought, that he seemed an institution in the community, hardly subject to removal by death." In this photograph, Munroe stands with his good friend, businessman E.B. Shelfer. (GCHS.)

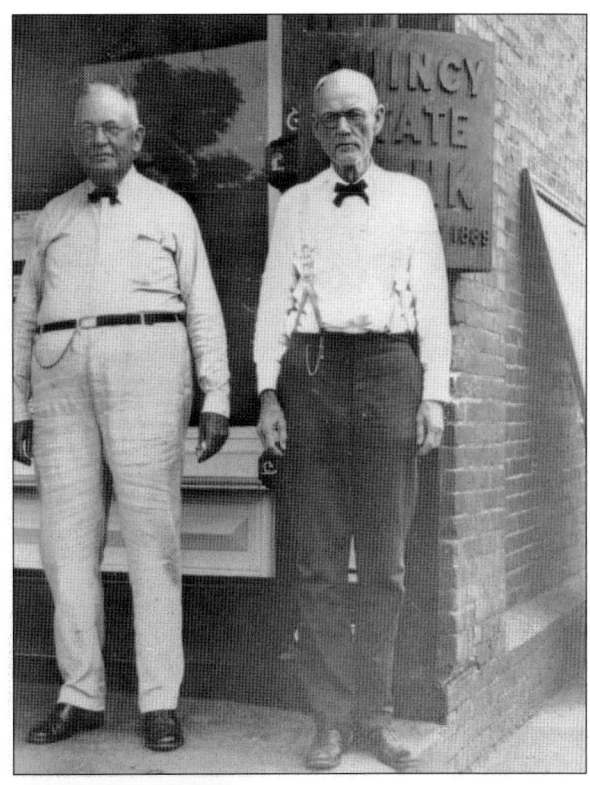

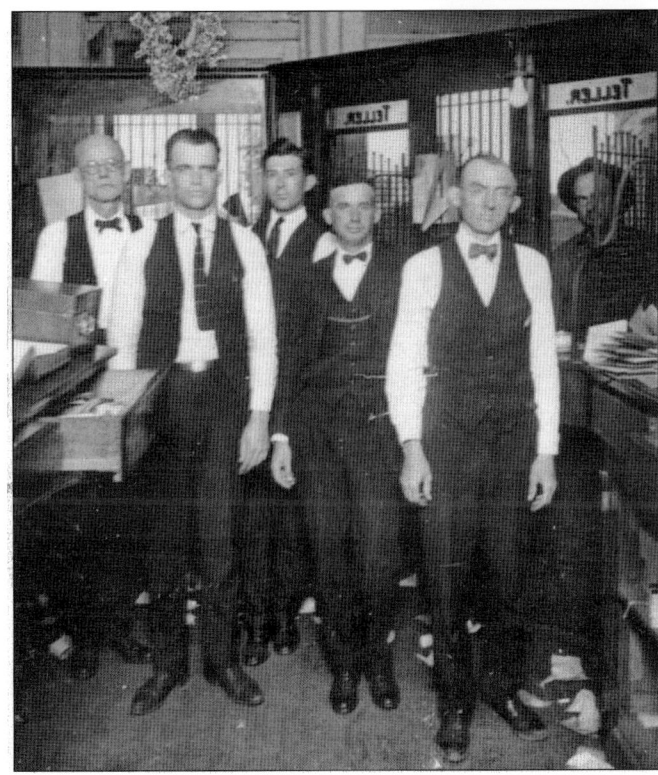

The staff of Quincy State Bank, shown here in the 1920s, are, from left to right, Mark W. "Mr. Pat" Munroe (president), John Bevis, L.D. "Neff" McMillan Sr., N.B. Jordan, and Willie Curtis. An unidentified customer stands at the teller's station. (Courtesy of the authors.)

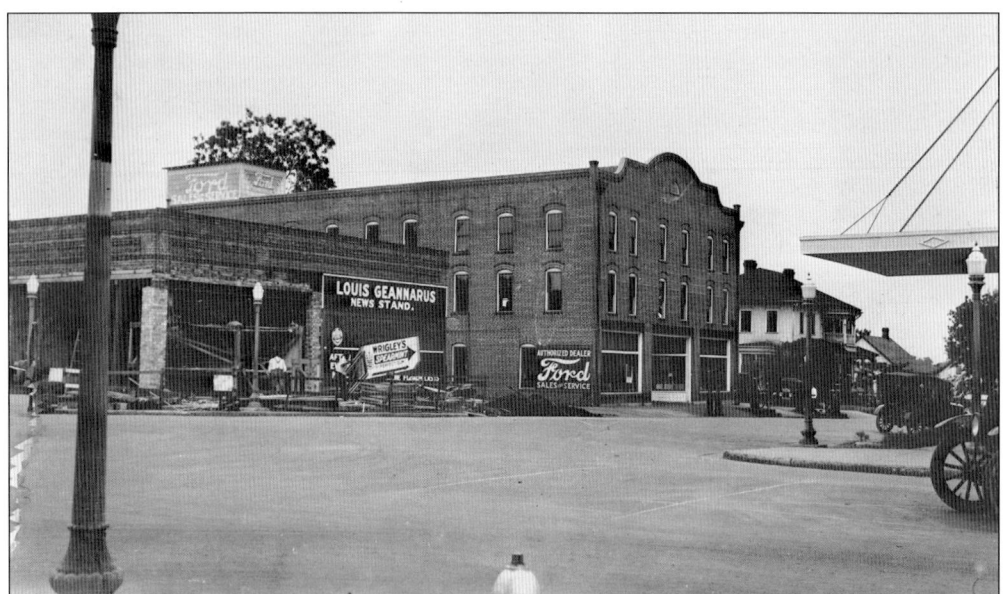

Before 1924, the Sharon Brothers store located on the southeast corner of Jefferson and Madison Streets was remodeled into a Gulf Oil service station. The north and west walls of this corner location were removed. Painted on the west wall is a mural advertising Louis Geannarus's newsstand, located just to the station's east. Next door is C.R. Shaw's Ford dealership, incorporated in 1917. By the 1940s, this corner location would become the Greyhound bus station. (SAF/FM.)

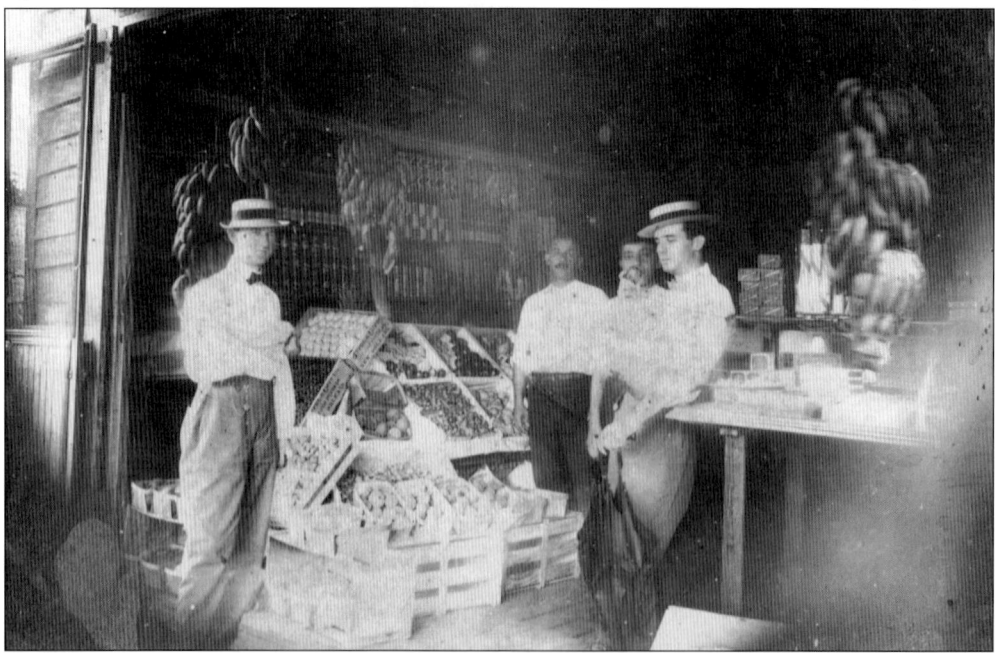

At the turn of the 20th century, Greek brothers Louis, John, and Apostle Geannarus immigrated to Florida from the Isle of Patmos. In Quincy, Louis and John operated a fruit and vegetable stand on the northeast corner of Washington and Madison Streets, opposite the Quincy State Bank. Shopping among the hanging bananas is dentist Dr. Bob Munroe (left) with the Geannarus brothers (center) and an unidentified customer. (Courtesy of the authors.)

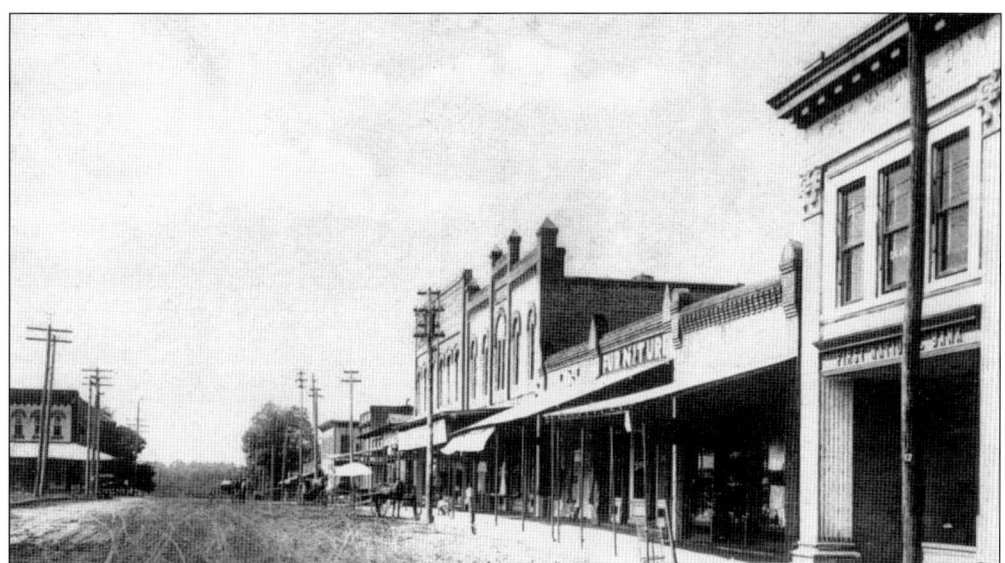

Hitching posts and telegraph poles line Adams Street in this photograph taken after 1914. The Market Hall is gone, and the Gee Building can be seen in the left background. To the west, buildings run continuously from the First National Bank in the right foreground to the F.P. May store. To its south are antebellum buildings, later removed for the 1922 Masonic Building. This view is looking south on Adams Street toward Tanyard Creek and the forest beyond. (Courtesy of the authors.)

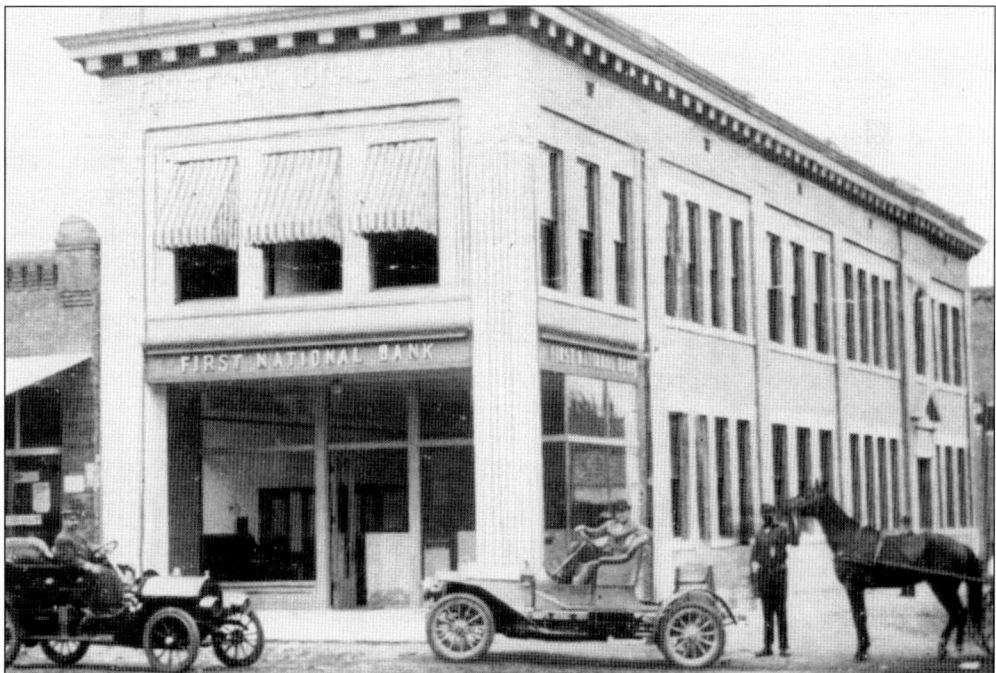

After 1907, on an empty lot at the southwest corner of Adams and Washington Streets, First National Bank built a magnificent Neoclassical building, at that time the finest structure fronting the square. Two fluted pilasters topped by Corinthian capitals anchored the facade, and a deep cornice with large dentil molding surmounted the entire structure. (Courtesy of the authors.)

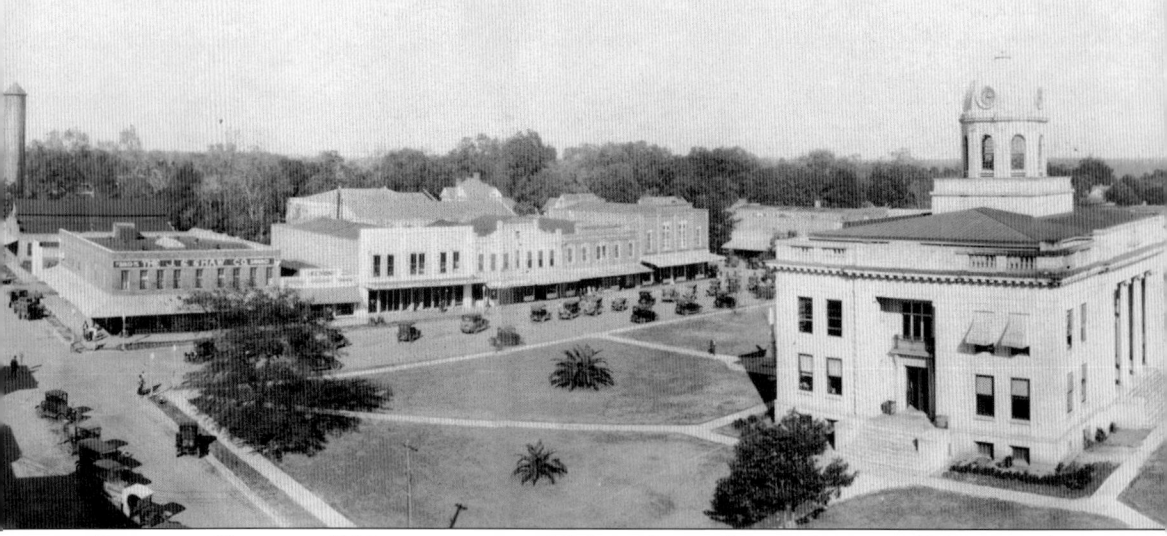

Downtown Quincy in 1926 was unrecognizable from the small town that existed 35 years earlier. The only link to its former identity was the war memorial, erected on the square's north side in 1884. The decayed village was swept away and in its place stood a city, symbolic of the economic success

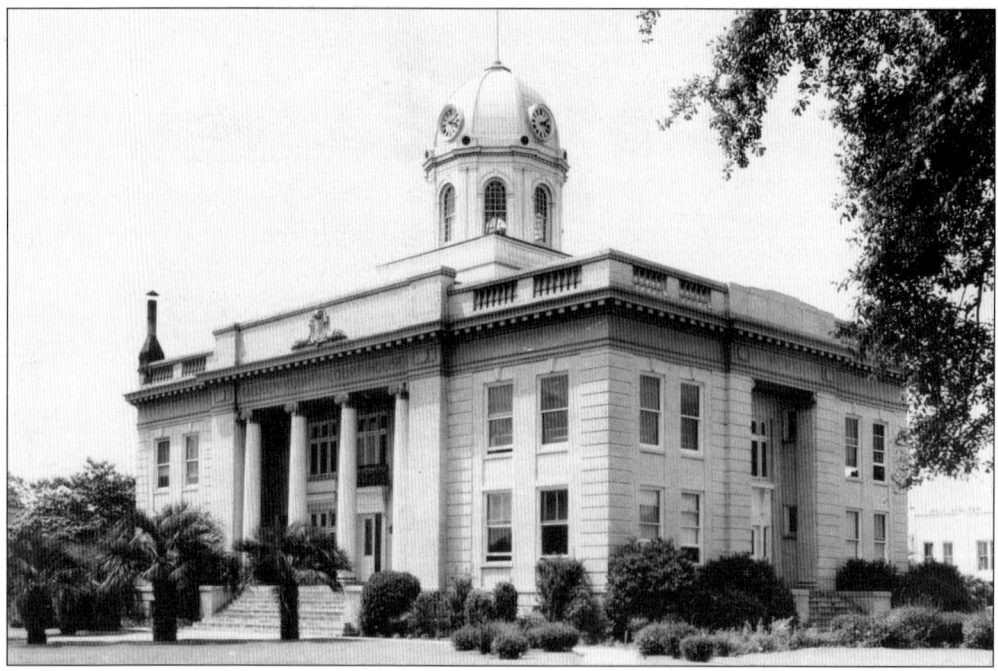

The stunning centerpiece of the square is the 1913 Neoclassical courthouse. Designed by the Atlanta firm Hentz and Reid, this building features two-story Ionic colonnades and architectural quoining at the corners and entrances. Above a parapet detailed with balustrades is a cupola modeled after Brunelleschi's dome in Italy. Hometown boy Hal Hentz attended L'Ecole des Beaux-Arts in Paris, where he studied design. His firm, founded in 1909, became recognized as a founder of the Georgia School of Classicism. Among his associates was Philip Shutze, designer of Atlanta's Swan House, and Edward Vason Jones, a designer for both the White House and the Diplomatic Reception Rooms in Washington, DC. (Courtesy of the authors.)

that shade tobacco had brought to Gadsden County. Growing dramatically, the town population went from 700 in 1890 to 4,000 in 1922. (Courtesy of the E.B. Embry family archives.)

Quincy's modern police department, founded in 1916 with an amendment to the city charter, was by mid-century housed in this small building straddling the courthouse sidewalk entrance on Jefferson Street. Taking cues from the courthouse design, this structure was constructed in matching brick with masonry quoining at the outside corners and a small replica of the dome on top. Surprisingly, it still exists, relocated to West US 90 in Douglas City between Quincy and Gretna. Shown kneeling are, from left to right, Assistant Chief Robert Edwards, Lex Belyeu, Slim Boyce, J.E. Hess, Eli Russell, Robert Gunn, Robert Martin (future Gadsden County sheriff), and Chief John Haire. Standing is secretary Doris Cross. (Courtesy of the authors.)

Festooned in flags and bunting, the new Masonic Building, on the corner of Adams and Jefferson Streets, prepares to welcome Free and Accepted Masons. Built in 1922, this four-story building completed the transformation of Courthouse Square. It housed R.E. Cantey's mercantile store on the ground floor and the Masonic Lodge Room on the fourth floor. (Courtesy of the authors.)

On November 11, 1912, Gov. Albert W. Gilchrist attended the cornerstone ceremony for the fourth Gadsden County courthouse. Standing among the visitors are members of Washington Lodge No. 2 wearing their ceremonial Masonic aprons. In attendance were prominent citizens Col. J.L. Davidson, Ross Harris, Ignatz Gardner, William Corry, and A.L. Wilson. (GCHS.)

Founded in 1902 by Norman Bell and Mortimer Bates, the Bell & Bates Home Center remains the oldest family-owned business in Gadsden County. This photograph shows the store's second location, on Washington Street facing the courthouse square. M.B. Bates Sr. (far right) stands with members of his staff and the proud owner of an automobile. In 1912, the company incorporated, and a new building was constructed on Madison Street, the site of today's Gadsden Arts Center. (Courtesy of Mark Bates.)

In 1924, Kwilecki's hardware store located to the southeast corner of Jefferson and Adams Streets. The Gee Building had formerly housed a saloon and grocery store, but Kwilecki's, one of a chain founded in 1860, would remain for 16 years before moving a half-block away. In this photograph, taken after 1924, it appears that Quincy's new streetlamps are being installed along Jefferson Street. In addition to a store sign, Wrigley's Gum is being advertised on a painted mural. (Courtesy of the E.B. Embry Family Archives.)

One can almost hear Irving Berlin's "Alexander's Ragtime Band" being played as the Quincy Fireman's Band (above) parades southward down Adams Street past its intersection with Washington Street. For years, the Quincy Fire Department (below) was at the heart of the community's social life, organizing a library and opera house and participating in sporting events with other fire departments. Fundraisers, raffles, bake sales, and picnics became common events sponsored by this dedicated group. (SAF/FM.)

The last store built on Washington Street was the J.S. Shaw Company, one of several department stores lining the square. It was replaced by the Quincy State Bank in 1961. In the 1930s, the store was decorated for the Christmas holidays by the Home Demonstration Clubs of Gadsden County. "Bless Everyone," a heartfelt message for all of the community, was an appropriate greeting given the religious diversity of Gadsden County in the late 1930s. (GCHS.)

As the optimism of the 1920s spread, the future seemed boundless. In Gadsden County, preparations were under way for the 1926 Chamber of Commerce Conference. The photographer has captured curious boys on their front steps as he points his camera west on Jefferson Street. Next door, the Hotel Quincy has started serving breakfast, and cars from all over the county have begun to arrive. All that remains recognizable today are the Masonic Building in the distance and the Pat Munroe House, still surrounded by its picket fence. (Courtesy of the E.B. Embry Family Archives.)

Edgar W. Scarborough Sr. began a general mercantile store on Chattahoochee's West Washington Street sometime after 1886. Successful in business, he also served as postmaster of the Chattahoochee post office until his death in 1914. The widowed Mrs. Annie May Scarborough married A.K. Gholson six years later, and the family operation became the Scarborough & Gholson Store and Post Office. In this photograph, A.C. Blount stands on the store's porch while "Uncle" Gadsden McMillan waits in his wagon. (GCHS.)

Located in the lowlands of western Gadsden County, River Junction, just south of Chattahoochee, lay near the junction of the Flint and Chattahoochee Rivers where they form the Apalachicola River. First river traffic, then railroads, transformed the area into a viable township. Unfortunately, fires and several major floods caused residents and businesses to finally relocate to their sister city just up the hill. Here, townspeople survey flooding surrounding the City Pool Room, Hotel Marie, Gadsden State Bank, and E.H. Boykin store. (GCHS.)

Across the railroad lay River Junction's Main Street, where entrepreneurs D.K. Palsgraaf and C.F. Jones conducted business and invested in their community. Operating a general store and drugstore, respectively, the men also became stockholders in State Bank No. 101, the Gadsden State Bank, in 1907. (GCHS.)

Scarborough & Co. at River Junction is once again inundated with floodwaters from the annual freshets of the Apalachicola River. Flooding in 1921, 1923, 1925, and 1929 eventually caused most businesses to move a few miles up the road to higher ground at Chattahoochee, leaving River Junction to wither. (SAF/FM.)

When the Georgia, Florida & Alabama railway between Cuthbert, Georgia, and Tallahassee laid tracks in 1900, adjacent land belonging to Sam Fletcher became the site of Havana, incorporated in 1906. An early view of the Havana business district on West Second Street appears to be looking north toward the warehouses in the distance lining the railroad tracks. (SAF/FM.)

This photograph, taken around 1911, shows Sixth Avenue in Havana, looking east. At the left, on the northeast corner of East First Street and Sixth Avenue, stands the Havana Baptist Church, built in 1908. Just beyond the adjacent houses stands Havana High School. (Courtesy of the authors.)

Before Havana's incorporation in 1906, building construction began adjacent to the railroad tracks near the intersection of West First Street and Eighth Avenue. Nearby were the town's original houses and, as a matter of necessity, a public well (at left), located at the village center. (GCHS.)

Summertime sales are displayed in this photograph from 1910. Havana's economy benefited from the record prices tobacco brought prior to 1907. New businesses opened, including W.S. Loyd's clothing store. Catering to "ladies and gents," the establishment featured hats by milliner Miss Lane and advertised "just received" Palm Beach "linene" skirts. Unfortunately, this store and many others would be destroyed in the fire of March 1916. (GCHS.)

With its organization as State Bank No. 95 in 1907, the Havana State Bank built this facility on Main Street. Weathering several years of uncertainty, the bank stabilized with the selection of E.H. Slappey as president in 1912 and by January 1916 had reorganized with a capital stock of $20,000. Ironically, almost two months later, this building would burn in the disastrous fire of March 16. It opened in a new location, on the southwest corner of Seventh Avenue and Main Street. (SAF/FM.)

Complete ruin dominates this view of downtown Havana following the catastrophic fire on the evening of March 16, 1916. After addressing an earlier fire, the townspeople retired, only to discover that another fire lay smoldering, erupting later that evening. In all, almost 25 buildings burned, and the commercial heart of the small community was destroyed. (SAF/FM.)

Proud storeowner O.P. Duggar had only a short while to ride the economic success that the train line and shade tobacco brought to Havana. Eradicated by the 1916 fire was his hardware establishment's inventory of enameled splatter ware, washboards, paint cans, and kerosene lamps. All of it was devoured by the raging inferno. (GCHS.)

Three abreast, rifles at shoulders, and flag unfurled, Boy Scouts march south down Havana's Main Street past Shelfer and Ellinor's storefront, Penn's Drugstore, and Seventh Avenue. Closely following are the majorettes and band from Havana High School, avidly watched by the surrounding crowd. With a fire truck thrown in for good measure, sometimes, a little Americana is just what folks need. (GCHS.)

47

Like River Junction, Greensboro developed as the result of transportation, specifically railroads. In 1889, J.W. Green purchased land in an area of west Gadsden County shortly before train tracks were laid and a depot was built. Centrally located among older settlements, the community became incorporated as the town of Greensboro in 1909. That same year, Green, in partnership with E.B. Fletcher, opened the Greensboro Hotel and, by 1927, became vice president of the Bank of Greensboro. (Courtesy of the authors.)

The Fletcher Company, more than any other farm supplier, became synonymous with Gadsden County's rural identity in the 20th century. Founded in 1908, the company was reorganized in 1914 as The Fletcher Company. The store stocked every conceivable item that a farm family could need for home or work, including clothing, footwear, feed, electrical appliances, paints, and irrigation equipment. Hearts were broken when "The Store" burned down in 1970. Shown here are, from left to right, Edward Fletcher (manager), Hal Fletcher (assistant manager), and T.B. Fletcher (president). (GCHS.)

"Badger, keep that mule a-turnin'!" implored Roxie Fletcher when, at the end of a furrow, a neighbor's conversation distracted her husband from work. That phrase became the family motto. A strong work ethic drove both parents, who determined that their children would have a better life. To these successful homesteaders, education was paramount: daughter Clara became a teacher; son Wells, a doctor; son Edward, a dentist; and oldest son Bertelle, a competent businessman. E.B. Sr. became president of the Greensboro Supply Company in 1908. (GCHS.)

If walls could talk. This iconic building, known as the Shady Rest, was a 1930s "juke joint" that existed at the intersection of State Road 12 and Shady Rest Road between Quincy and Havana. In the 1980s, the roadhouse was moved a few miles down the highway and incorporated into a collection of historic buildings, part of the Nicholson Farmhouse Restaurant complex. (SAF/FM.)

The last of Florida's water-powered mills, Shepard's Mill exists as a relic from pioneer days. Located east of Greensboro, the mill was built in 1875 at the headwaters of Telogia Creek. Through the years, it has served as a sawmill, gin mill, and power plant, but it was best known for its water-ground cornmeal. Owners later expanded into surrounding counties, supplying a product line that included hushpuppy mix, syrup, and flour. The mill lies dormant today, waiting for its wheel to turn once again. (SAF/FM.)

Gretna, like Greensboro, developed with the railroad in the late 19th century. Attracting entrepreneurs, the area began to grow when businessman W.P. Humphrey established a turpentine still around 1900. Working with sons Duncan, Jim, and Ben and son-in-law J.W. Mahaffey, Humphrey expanded operations to include a sawmill, cotton gin, and blacksmith shop. The company hired workers, and houses and a commissary were built. In 1909, the area was incorporated into the town of Gretna, an interpretation of the local African Americans' name for the area. (GCHS.)

Townspeople gathered in front of the post office in 1909 to pose with the first car in Gretna, a runabout driven by Marguerite Humphrey. Among the assembled carriages and people stands store owner Jim Mahaffey (left) and postmistress Mrs. Johnson (wearing white), and to her left, the fourth man over, stands the inspiration for it all, W.P. Humphrey (the bearded man). (GCHS.)

Gadsden County in the late 1800s was sparsely populated, with small farming communities of churches, schools, general stores, and post offices. Early pioneers in the western portion harvested virgin pine forests to produce lumber and turpentine, becoming prosperous and expanding into livestock. The construction of a railroad through this area opened the county to the outside world, and with prosperity came crime. "Wanted" posters became common in community post offices, warning locals to be on the lookout, as was the case in this photograph at Mary VanLandingham's store and post office in Juniper. (Courtesy of the authors.)

Three
CABINS TO CASTLES

This cabin, among the oldest in the county, was built in the mid-1820s by Dr. Malcolm Nicholson, who had emigrated from Scotland in 1775, arriving in Florida around 1820. Slaves built the house using virgin timber and bricks kilned on the 4,000-acre plantation. (SAF/FM.)

Photographed in 1900, M.B. Bates stands in front of the house her family had occupied for over 50 years. Built as a log cabin around 1826, this Mount Pleasant house was acquired by Joshua Davis after 1830. His plantation home may have served as a stagecoach stop on "the upper road," the section of US 90 connecting Quincy to Chattahoochee. It is an example of a Gadsden County gentrified pioneer house, a "dressed" timber structure with obvious additions and improvements. (GCHS.)

Photographed in 1897, homesteader Walter Walsh and his family line up in front of their log home on Fairbanks Ferry Road near Concord. Utilizing a quintessentially Southern house construction, the individual cabins, known as "pens," are separated by an open breezeway called a dogtrot. Combined with a roof overhang, the porch and dogtrot provided a cool area for socializing. (Courtesy of Angela Cassidy, Gadsden County, FLGenWeb Project.)

Constructed off of West Jefferson Street, on the probable site of Gadsden County's earliest courthouse, the William and Hector Bruce House may be dated as early as 1825. The home is unusual in several respects, including 16-inch-thick masonry walls and second-floor living quarters, identifying it as a "raised" cottage. Holes located in the gabled ends and a rumored safe room contribute to the oral tradition that it is among Gadsden County's earliest houses built to withstand Native American attacks. The house currently serves as Talquin Electric Cooperative's headquarters. (GCHS.)

In 1913, Lonnie John Clark (holding his son Henry Clyde) and his wife, Eva Priscilla Wells (holding daughter Evelyn Clark), pose with the family's new automobile in front of their Greensboro home. (SAF/FM.)

Once located on the southwest corner of Washington and Stewart Streets, this Creole-style cottage, typical of many built in the 1830s, represented the first generation of Quincy's "designed" houses. There is a classical influence in the dormer pediments and square Doric columns, and entrances are highlighted with simple transoms. This style of house is also referred to as Gulf Coast Vernacular. The home was removed by the 1960s, replaced by a fire station. (Courtesy of the authors.)

On a spring day in 1900, friends Sarah Allison (left) and Bessie Munroe stand on the front steps of the Greek Revival Allison House. Built around 1840, this house typifies the common cottage style of antebellum Quincy. Simple wood Doric columns define the portico, surmounted by a pediment tied in to the house's hipped roof. After 1922, this house was remodeled and exits today as the Allison House Bed and Breakfast. (Courtesy of the authors.)

In this photograph taken sometime after 1877, the family of Col. R.H.M. Davidson assembles on the portico of the raised Greek Revival cottage built by his father, Dr. J.M.W. Davidson, in the mid-1830s. A recent renovation of the house substituted Carpenter's Gothic columns to support the portico's pediment. Unfortunately, this enchanting home on Madison Street, one of antebellum Quincy's finest, would be demolished in 1970 for a parking lot. (Courtesy of the authors.)

The Reverend N.P. Quarterman stands, hat in hand, in front of the Old Presbyterian Manse on Corry Street, its front door ajar. Built around 1870 for US congressman Col. R.H.M. Davidson, this Creole-style cottage features the identical Carpenter's Gothic detailing on its columns and railings as does the remodeled Dr. J.M.W. Davidson home (above). It is presumed that this house was constructed as shown and that the older house was renovated to match. (Courtesy of the First Presbyterian Church, Quincy.)

Located on North Duval Street, the Harris-Munroe-Gardner House was built around 1840, constructed by Isaac R. Harris as a one-and-a-half-story cottage. Harris, a Mason, was instrumental in creating Quincy's early school system, a fortunate circumstance for the house's next owner, William Munroe. A Scottish immigrant and father to 22 children, Munroe purchased this house in 1850. After 1913, the cottage was remodeled by William L. MacGowan into the two-story house shown here. (Courtesy of the authors.)

Dapper in white shirtsleeves and summer boater, Ignatz Gardner poses on the front steps of his home. He is facing in the direction of buildings that represented the industry that brought him to Gadsden County: shade tobacco. Located on Jefferson Street, his home stood directly across from the American Sumatra Tobacco Company. Just north stood the Max Wedeles Tobacco Company, where Gardner succeeded its namesake as president for more than 20 years. (Courtesy of the authors.)

In midsummer 1908, natural awnings of creeping smilax cast lengthening shadows across the facade of the Jones-Lines-Munroe House. Framed by square Doric columns, Hattie Munroe sits rocking, her small granddaughter Bee clutching at her voluminous skirt. There are plants to be watered and, later, a good sweeping of the dirt yard before feeding the family livestock. A simply detailed Greek Revival cottage, the North Jackson Street house was a gift to Munroe's parents, Robert and Rebecca Jones. Her grandfather Nathaniel Ziegler built it with materials and resources from his plantation north of Quincy. The original property encompassed one half of a block. This house, completed in 1853, was passed down through five generations of the maternal line. It remains one of three Quincy homes to maintain family ownership since antebellum times. (Courtesy of the authors.)

Under a portico draped with smilax and ivy, Judge P.W. White and daughters Pinkie (left) and Minnie stand at the entrance of their King Street home (above). Judge White was a remarkable man whose life spanned Gadsden's entire 19th-century history. Judge, Confederate major, and Florida's chief commissary officer, White purchased this house from his wife's uncle in 1849. Built originally as a one-and-a-half-story cottage in 1843, it was enlarged in 1856. Architecturally, it is one of Quincy's antebellum jewels, featuring identical north and south porticoes, fluted Doric columns, pilasters, and window and door casings with rosettes. The balcony railing is highlighted by a vertical diamond wood pattern. This Greek Revival structure was the site of Judge White's annual birthday celebrations, as seen in the below photograph. In 1921, the structure became the Centenary United Methodist parsonage. (GCHS.)

The Austin-Curtis House (above), now gone, stood at the northwest corner of Washington and Jackson Streets. The simple Victorian cottage reflected the architectural detailing in vogue after the Civil War, including simple stick-style railings and a jigsaw porch parapet. This was the home of Colonel and Mrs. Henry Curtis (seated on the top step in the photograph below). Family and friends shown on the veranda in the photograph below may be anticipating one of Mrs. Curtis's famous "Pound Parties" or perhaps one of her musicales. An inventive party-giver, Mrs. Curtis often entertained children with candy pullings and games. (Courtesy of the authors.)

Guests and patrons gather for a noontime meal of fried chicken and turnip greens. "Love House" stood at Jefferson Street, between Jackson and Monroe Streets across from the American Sumatra Tobacco Company. Built in 1832 by pioneer Jesse Coe as a home for his daughter Sarah, the dwelling had become a boardinghouse by the time this photograph was taken. It shared characteristics with other early Gadsden County houses, including a Georgian central hall floor plan and a hipped roof. Love House would disappear by the 1920s. (Courtesy of the authors.)

Sitting on her front porch, Lena Ottinger watches for passersby. Photographed from an upstairs window of Love and Herrin General Mercantile Store, this house was built before 1884. The eave brackets and modest spindlework porch detailing are characteristic of the Folk Victorian style. The Ottingers, Adolph and Lena, were living in Gadsden County by 1880. This house was gone by 1907, replaced as Quincy's commercial district grew. (Courtesy of the authors.)

Reflected in a clouded mirror, the once-imposing William Corry House peers through the mists of time. A solitary figure under the porch gazebo waits for visitors to admire her Spanish bayonet. Located on the northeast corner of King and Duval Streets, this house was constructed in the 1890s in the spindlework variation of Queen Anne. Particularly noteworthy are the geometric railings and porch frieze, gable shingles, and the rare square-corner tower cantilevered at the second floor. The house also featured window sashes bordered with stained glass, a detail shared with the Pat Munroe House (1893). Removed in the 1950s, all that remains of the Corry House is the curbside carriage step, waiting for guests who will never call again. (GCHS.)

A somber grouping of cousins, sisters, and aunts pose on the upper and lower verandas of the Dr. Charles A. Hentz House, on North Jackson Street. Dr. Hentz, a noted Gadsden diarist, was father to Hal Hentz, architect of the current Gadsden County Courthouse and principal of one of Atlanta's distinguished architectural firms. Built in 1890, this Folk Victorian house still stands but is very much remodeled. (GCHS.)

A crown jewel among Quincy's Victorian castles, the newly finished John Lee McFarlin House shines on a late winter's afternoon in 1895. Built in a style described as Free Classic, a variation of Queen Anne Victorian, this house was designed by architect William Carr and represents the height of that style, with its castle turret, stained-glass, Palladian attic window, paired classic porch columns, patterned shingles, and elaborate exterior and interior millwork. Built by a successful tobacco planter co-credited with originating slat tobacco shade, the house now functions as a bed-and-breakfast, the McFarlin House, where guests can enjoy the gentility of days gone by. (GCHS.)

Once upon a time, visitors entering Quincy were enchanted by the manicured homes and lofty oaks lining West Jefferson Street, including this impressive Folk Victorian built by A.L. Wilson, a prominent local merchant. Porch shades lowered, ceilings glistening, and rockers waiting, the two-story veranda decorated with jigsaw trim is reminiscent of a steamboat's gallery. (GCHS.)

The Dr. J.E.A. Davidson–C.W. Thomas House, located on the northeast corner of King and Love Streets, is a masterful statement of the prosperity that tobacco brought to the county at the beginning of the 20th century. The home was built in 1859, and the owner's son, W. Harper Davidson, embellished the structure "to please his doll-like wife Bessie." The Neoclassical two-story portico, highlighted by six Corinthian columns and topped by the front gable's Palladian window, was added after 1908. (Courtesy of the authors.)

May Stockton poses patiently, hands clasped behind her back, next to her husband, F.P. May, in front of their picturesque home on North Jackson Street. The "new" house was finished in record time. Building contractor A.S. White found success in Quincy, beginning in 1892 with this house and ending shortly before his death in 1911 with completion of new headquarters for the flourishing F.P. May Drug Company, itself a community fixture for over 100 years. Client Frank May was born in 1852 on this property in a simple wood cottage built by his father in the 1840s. To that same house, F.P. would bring his bride, May Stockton, 27 years later. Two generations would be raised in the May Cottage before Frank built this intricately detailed Queen Anne home, which still stands today. Romantically embellished with Juliet balconies, scrollwork, and latticed garden gazebo, this house would be home to four generations of May descendants before being sold and sensitively restored, using this same photograph, by New South Builders in 2007. (GCHS.)

Brothers Edwin and Walter Graves did everything together. Their business, the Graves Lumber Company, began in 1895 and diversified into cattle ranching, real estate, and citrus production. Incorporated in Florida in 1910, their logging interests in Liberty County gathered momentum, and by 1919, the company became the principal employer in Hosford, building a hotel, housing, and a commissary. The brothers provided all of the support for their vast timber holdings, including transport trains (below). That same year, Edwin instructed his contractor to build a house matching the one Walter bought on Quincy's Fourteenth Street. The instructions included one stipulation: the home had to be larger, to accommodate Edwin's growing family of six children. The result, seen in the above photograph, was a balanced Neoclassical house featuring a two-story portico, Doric columns, fanlight, wraparound porch, and porte-cochère. J.E. Graves became Quincy's longest-serving mayor, for 15 straight years between 1925 and 1939. (Above, courtesy of the Frank Allman family; below, GCHS.)

Addison Mizner designed Palm Beach in the Spanish Colonial Revival style, and architect Alvin Moore did the same for Ignatz Gardner in Quincy. Constructed between 1928 and 1931, the Gardner-McCall House features a "bell-tower" chimney, carved stone door surround and entry newels, tile wainscoting, arched casement windows, and Mission roof tiles. Complimented by landscaping designed by J. Leon Hoffman, this house could easily blend in with any Mizner design. It remains pristine, the last built of the great houses fronting King Street in the Historic District. (Courtesy of the authors.)

Built by George D. Munroe around 1898, this Free Classic variation of the Queen Anne style is distinguished by paired columns and a generous porch, and it boasts more original stained glass than any other house in Quincy. This lovely home, which still exists today, is one of four great houses anchoring the intersection of Love and King Streets. (GCHS.)

The twin-gabled James Little Davidson–Suber House, built in 1914 by W.C. Cooper, exists as Quincy's finest example of a late Queen Anne cottage. An architectural form seen in other neighborhoods, this East King Street house is the largest and features original metal roof cresting and paired classic porch columns. A majestic oak in front has long been associated with an early pioneer, Judge Pleasant Woodson White, who is said to have played there with Native American children in the 1820s. (Courtesy of the authors.)

Their summer play interrupted, the neighborhood gang poses, bikes in tow, with the proud R.M. Davidson family in front of their newly completed 1905 home on North Corry Street. Mr. Davidson sits in his porch rocker, the very picture of a successful businessman: daughter at his side, his dog Carlo at his feet, and an adoring wife and baby looking on. (Courtesy of the authors.)

The Underhill-Wedeles House was among the most architecturally interesting on King Street. A Colonial Revival with an Adams oval window, Palladian second-floor window, and classic balustrade, the home also exhibits a Craftsman influence in its open eaves and exposed rafters. Constructed in 1905 by G.M. Underwood, this became the home of the Max Wedeles family, who owns it still. (SAF/FM.)

"I want a child hanging out of every window!" The story goes that Mark Welch Munroe said this when he built his Queen Anne home at the corner of Jefferson and Duval Streets. "Mr. Pat" got his wish, with 20 windows to spare. Father to 18 children, Mr. Pat, a prominent banker, constructed his spindlework Victorian in 1893. In 1976, John W. Bates, a grandson, purchased this family home, generously donating it to the city. The building now houses the Quincy Garden Center. (GCHS.)

Rolled porch shades and flowering beds hint at white summer slipcovers inside this magnificent home built by prominent businessman E.B. Shelfer. A civic-minded shade tobacco producer, Shelfer served as a director of both the Quincy State Bank and Havana State Bank. Designed by local architect William Carr in 1903, the house sits on the presumed site of a stagecoach line operated by Col. P.A. Stockton in the 1860s. This property may have had a public well from which townspeople drew water as late as the 1890s. Featuring metal roof cresting, corner pilasters, arched window and classic columns, this house is another example of Queen Anne architecture in the Free Classic styling. Located on the northeast corner of Franklin and Madison Streets, it was sensitively restored and expanded in the 1990s by the architectural firm Lee and Bridges for Shelfer's granddaughter. (Courtesy of the authors.)

In the early 20th century, West Jefferson Street was a quiet, shady residential area lined with homes of prominent citizens like Dr. W.S. Stevens and his wife, the former Annie Bailey Kent. Their lovely Victorian home, located near the Tanyard Branch, was no doubt the scene of many social gatherings. It was large enough to accommodate the growing Stevens family, which eventually included eight children: six boys and two girls. The house was torn down in 1974 to make way for the encroaching commercial district. (GCHS.)

Looking like a fairy-tale castle, surrounded by a moat of cast iron and marble, the R.K. Shaw–Embry House greets a visitor unexpectedly. Sited at a bend on the northwest corner of Sharon and Adams Streets, this house remains among the most picturesque in town, and it is certainly the most eclectic. This Queen Anne exhibits characteristics of both the Spindlework and Free Classic styles in its gable detailing, roof brackets, dentil molding, paneling, and classic columns. The turret and roof, intricately clad in patterned shingles, are nods to the Shingle style. Built in 1895 by Roderick K. Shaw, this house was later purchased by the E.B. Embry family. Both businessmen were involved in Gadsden's shade tobacco industry; Shaw is co-credited with introducing slat tobacco shade, and Embry established the Embry Tobacco Company, later part of the King Edward Tobacco Company. Interestingly, this house was one of the first to install a telephone, in 1898, after Shaw discovered the business advantages of Bell's invention. (SAF/FM.)

The resplendent Carl F. Jones House in Chattahoochee waits to receive visitors behind a parterre of flowerbeds and walkways outlined by a profusion of angled brick borders. A symmetrical Folk Victorian highlighted with spindlework railings and jigsaw corbels, this house had the delightful addition of a porch gazebo. Carl Jones was a River Junction druggist whose store first housed the Gadsden State Bank, chartered in 1907. (GCHS.)

Edgar Harrison Boykin was a self-made man. Born in 1873 in Chattahoochee, he became the family provider at 12, and by 25 opened his first store. While heading E.H. Boykin & Company, Merchants in River Junction, he organized the Gadsden State Bank and was elected president a year later, in 1908. His simple Queen Anne home on Chattahoochee Street presented a becoming symbol of his status. Conservatively detailed as a Free Classic variation with Doric columns, this home remained Edgar Boykin's residence until his death in 1957. (GCHS.)

A Shetland pony is just about the nicest gift any boy could get, and Edgar W. Scarborough Jr. was justly proud of his. Decked out on his birthday, Edgar sits astride "Midget." His father, the owner of Scarborough & Company in River Junction, stocked everything young Edgar was wearing, from his lace-up shoes to his straw brim hat. But circumstances would alter the joy of this photograph; the fine Folk Victorian home built on South Bolivar Street would burn down days after Christmas 1926. (GCHS.)

Two young girls venture from the shaded sanctuary of A.K. Gholson's porch. This Colonial Revival home made an impression when it was constructed on South Bolivar Street after 1927. It featured a central balcony flanked by Ionic pilasters supporting a pediment outlined in oversized dentils, a detail that continues along the roof edge and end gables. Below, the wraparound porch columns are grouped in threes, each surmounted by an Ionic capital, a nice counterpoint to the simple balustrades. (GCHS.)

Four
Hospitals and Medicine

A recent graduate of medical school, young Dr. John M.W. Davidson, with his wife, Mary J. Sylvester Davidson, arrived in Quincy by wagon train full of pioneer spirit. Like scores of other Scottish Presbyterian emigrants from the Carolinas, Davidson was drawn by the area's reputation for productive and available land. He operated a successful medical practice for more than 50 years and owned a pharmacy in Quincy. In early 1829, he and Mary opened Woodville Academy, south of Quincy "at the crossroads," teaching the classics. (Courtesy of the authors.)

Florida's State Hospital, Chattahoochee, Fla.

The Federal Arsenal at Chattahoochee, built in the 1830s, has served several purposes in its 180-year history. Built as an arms depot, it was seized by Confederates and used as a staging area during the Civil War. After returning to federal control, it was used by the Freedman's Bureau, aiding former slaves with food, housing, medical care, and education. In 1866, the arsenal and land was ceded to the state of Florida for use as a state penitentiary. It became the State Hospital for the Indigent Insane in 1876. Renamed the Florida State Hospital, the original officer's quarters served as the Administration Building (below). One of the oldest buildings of its kind, it is listed in the National Register of Historic Places. (Courtesy of the authors.)

A 1904 graduate of Meharry Medical College, Dr. William Spencer Stevens became the first African American to open a medical practice in Quincy. He treated patients during the 1906 yellow fever outbreak and the influenza epidemic of 1918. The Stevens Hospital opened on January 1, 1931. Dr. Stevens, finding poor school facilities a great hindrance to progress, labored to improve educational facilities and, in 1914, was named supervisor of Quincy City Schools. In 1925, he led the campaign to expand Dunbar School. When this was accomplished, officials renamed the facility W.S. Stevens School in his honor. (SAF/FM.)

On February 8, 1910, Dr. William Stevens married Annie Bailey Kent (far left) at the home of her parents in Quincy. A reception followed at the newlyweds' home on Jefferson Street. Their attendants were Dr. Stevens' sister Maggie (second from right) and his aunt, Maggie Proctor (far right). Dr. and Mrs. Stevens had eight children, six sons and two daughters. (SAF/FM.)

The first Gadsden County Hospital was the former home of Capt. James Evans and his wife, Sallie Booth Evans. Built in 1859, this elegant two-story building stood at what was then considered "the edge of town on the way to the depot" on the top of the West Washington Street hill. Just after the Civil War, the house was sold to Judge Jonathan W. Malone and his wife, Annie Hemming Malone. The structure was later removed when the new county hospital (below) was built. The site is now home to Thomas Memorial Baptist Church. (Above, courtesy of Angela Cassidy, Gadsden County, FLGenWeb Project; below, GCHS.)

Five

CHURCHES AND SCHOOLS

Communities are formed through bonds of family, school, and church, so the sight of young workmen, some no doubt members, clambering across the roof of the Greensboro Methodist Episcopal Church must have been heartwarming. The building was constructed in 1908 as a station church on the Sycamore circuit. The congregation had its beginnings in services and classes organized two years earlier by Reverend F.E. Sternmyer. Services were held weekly beginning in 1956. This Gothic Revival building exists today as the Greensboro United Methodist Church. (GCHS.)

The simple Gothic Revival building in the left photograph became the home of the First Baptist Church when the cornerstone was laid on October 1, 1896. Located on the southeast corner of Franklin and Monroe Streets, it was the embodiment of an Evangelical dream belonging to Mr. and Mrs. Alexander S. White. Hired to build the F.P. May House in Quincy, Alexander relocated from Thomasville, Georgia, and quickly realized that Baptists were not represented. He set about rectifying the situation and, with Mrs. Jeff Davis, began afternoon Sunday school classes. Growing quickly, the congregation was able to purchase this location, where services were held until construction of a second sanctuary nearby began in 1918. Incredibly, the magnificent Neoclassical building (below) took almost eight years to build. It featured a central dome set above a curved portico supported by Corinthian columns. Inspired by Byzantine church designs, the unknown architect was clearly talented, as were the building's contractors. One of Quincy's crown jewels, the second sanctuary stood for over 50 years before being demolished in the late 1970s. (Left, GCHS; below, courtesy of the authors.)

The intersection of King and Madison Streets must have been a captivating sight in antebellum Quincy. At three corners stood Greek Revival homes, and on the northwest corner facing King stood the dignified First Presbyterian Church, a simple framed Greek Revival building surmounted by a steeple. The day after this photograph was taken in 1923, the old church was torn down to make room for a new edifice. (Courtesy of the First Presbyterian Church, Quincy.)

"Come to the church in the wildwood." The opening words to this familiar hymn could apply to Old Philadelphia, the oldest meetinghouse in continuous use in Gadsden County. By 1822, Presbyterians from the Carolinas and Georgia had begun worshiping in Gadsden County, and in 1828, they constructed their first sanctuary on this site, which was a gift to the congregation from Allen McKenzie. Old Philadelphia ended regular services in 1912 but remains a mother church to numerous Presbyterian congregations throughout the area. Each spring, homecoming beckons the faithful back to the church in the wildwood. (GCHS.)

In the above photograph, taken sometime prior to 1896, members of the Centenary Methodist congregation mingle under the portico of the Greek Revival church, dedicated on October 25, 1839. Designed and built by Madison Wilson, the church had a central wood partition separating the worshipers into groups of men and women. To the south stands the 1889 parsonage, the first specifically built to house the resident minister's family. In 1896, the second floor of the church was removed and the exterior reclad in red brick in the fashionable Gothic Revival style shown below. Replete with a new spire and stained-glass memorial windows, this building would continue to occupy its corner until 1918. A new sanctuary designed by renowned architect Hal F. Hentz reused the 1896 windows and pews. (GCHS.)

St. Paul's Episcopal Church began services as early as 1834 in Quincy, and by the end of 1839, a sanctuary was constructed at the northwest corner of King and Adams Streets on land donated by the Stockton family. This early building, consecrated on February 21, 1841, saw hard use as a hospital during the Civil War. Within its walls, wounded Union soldiers were operated upon, many losing limbs to amputations. Decrepit and unused, the original sanctuary was replaced in 1892 by a modest Gothic Revival frame building (above). Remodeled in 1928 (below), it has the distinction of being Quincy's oldest existing sanctuary. (Above, GCHS; below, courtesy of the authors.)

METHODIST CHURCH, HAVANA, FLA.

The Gothic Revival style seemed appropriate for churches constructed at the beginning of the 20th century. Located on Ninth Avenue, the 1907 Salem United Methodist building was a charming example. This, the congregation's third sanctuary, was a survivor of Havana's 1916 fire. A corner entry was accented by rose windows topped by an open belfry to announce services each Sunday. At the sides, intersecting gabled wings featured matching transit windows. It was replaced by a new building in 1940. (GCHS.)

Organized in 1866, the first congregation of Quincy's African Methodist Episcopal Church met in members' homes or at outdoor locations. In 1867, church members bought a lot and built the Arnett Chapel on the southeast corner of Duval and Clark Streets. This was Gadsden County's first African American church. An early map shows a Masonic Hall across from the church, an Odd Fellows Hall south of the church, and school grounds to the west. This area was truly the cultural and religious heart of Quincy's African American community. Arnett Chapel was named for Rev. Benjamin W. Arnett, presiding bishop in Florida from 1888 to 1892. The present-day Romanesque Revival church began holding services in 1940. (GCHS.)

The AME clergy members seen here in 1890 are, from left to right, Reuben Brooks, Bishop Morris Marcellus Moore, Bishop Benjamin W. Arnett Sr., Bishop Josiah H. Armstrong, and James S. Braswell. Marcellus Moore, DD, was born on March 15, 1865, in Quincy, and the church was named for Bishop Benjamin Arnett. (GCHS.)

Members of Old Mount Pleasant Methodist Episcopal Church, Gadsden County's oldest pioneer congregation, line up for a photograph around 1915. This reserved meetinghouse, dating from 1886, was the fourth built since the church's beginning in 1824. It was erected to replace a building that burned down during the Civil War. Early missionary efforts concentrated on the African American slave population, including outreach to the county plantations. Unfortunately, time and termites wreaked havoc on the frame structure, and it was removed in 1976. However, weekly services continue at the same location, in the fifth building housing the Old Mount Pleasant United Methodist Church. (GCHS.)

The Gretna Presbyterian Church was organized at a revival meeting on October 13, 1905. In 1908, a meetinghouse was built on land donated by W.P. Humphrey. (GCHS.)

In 1920, an entrance, steeple, and bell were added to the simple meetinghouse of the Gretna Presbyterian Church. (GCHS.)

The first Quincy Academy, built in the 1830s, was a wood structure near the northeast corner of Adams and King Streets. In 1849, during a devastating fire in Quincy, the building went up in flames. The present brick structure (above) was built shortly after, offering classes in the basics as well as in geography, history, rhetoric, philosophy, botany, chemistry, geology, and mineralogy. During the Civil War, it was used as a hospital, and in 1912 it served as the Gadsden County courthouse. It was used as a kindergarten during the Depression and later became a lending library. Today, it serves the community as an emergency food pantry operated by the Presbyterian Church. The Quincy Academy had the reputation of being the best school in Florida and continued operating until after 1900. Below, area instructors gathered at the academy. (Courtesy of the First Presbyterian Church, Quincy.)

Possibly the oldest African American school in Quincy, the city school on West Clark Street was also known as Old Mitchell Hall. A quintessential one-room schoolhouse, this old building was a hub of learning, and many of the students seen here were possibly the first in their families to learn how to read and write. Included in the photograph are Rev. Cupid Aleyus Whitfield, Mrs. Ephrom Jacob, and Leila Jones Preston. (SAF/FM.)

Born in 1868 in Gadsden County, Cupid Whitfield was the son of Cato and Amanda Whitfield, former slaves of Gen. William Kilcrease, father of Gov. Albert Gilchrist. Cupid was educated and began teaching school at 16, becoming known as one of the leading African American teachers of Gadsden County. In 1889, he married Rebecca Z. Goodson, and they had 14 children. He received a doctor of divinity degree from Morris Brown College in 1906. Reverend Whitfield was professor of English literature and ancient history at Edward Waters College in Jacksonville and later was principal of the college. (SAF/FM.)

The Rosenwald Fund, which helped build well-designed schools for African American students throughout the South, built the Dunbar School in Quincy in the 1920s. Julius Rosenwald was a clothier, manufacturer, business executive, philanthropist, and part-owner of Sears, Roebuck & Company. He established the Rosenwald Fund after meeting Booker T. Washington in 1911. Rosenwald created his fund to improve the education of Southern blacks by building schools, mostly in rural areas. Dunbar School taught all 12 grades, unusual at the time as many rural schools only went through eighth grade, requiring students to leave their homes and families to further their education. Principal R.H.L. Dabney is in the upper left of the photograph. (SAF/FM.)

Respected educator and beloved teacher Hattie Paramore stands with her last class at Dunbar School in 1928. Paramore was born about 1880. The home she shared with her husband, John, on South Adams Street was not far from the school. Carter-Paramore High School was named to honor her and Jenkins Carter. (SAF/FM.)

Braving the cold on a winter's day in 1928, Dunbar School upperclassmen pose on the school steps for their class portrait. Shown here are, from left to right, (first row) Mildred Humphrey Moton, Viola Harvey, Leila Preston Akin, Josephine Anderson Jemmott, Rosa Flemings Burnside, and Sadie Jones Byrd; (second row) principal Annie Kent Stevens, James Andrews, Lucy Smith, Isaac Gainer, Rutha B. Gainer, Mack Byrd, and teacher Letetia Taylor Byrd; (third row) Willie James Anderson, James Johnson, Chauncey Gainer, and Horace Woodard. Principal Annie Kent Stevens was the wife of Dr. W.S. Stevens. (SAF/FM.)

Dunbar School was later renamed Stevens School in honor of physician and community leader Dr. William S. Stevens. Here, Stevens School faculty members sit for a yearbook portrait. Shown are, from left to right, (first row) T.L. Sherman, Annie Ruth Henderson Jackson, Robert Stevens (son of Dr. W.S. Stevens and Annie Kent Stevens), Lucy Smith, principal LaSalle Leffall, Sarah Bennett, Hazel King, Inez Stevens Jones, Minerva Laster, and Genevieve Lowe; (second row) Polly Preston Simms, Rachel Williams, Arthur Jones, Irene Caldwell, Eloise Anderson, Winifred Harden, Bernard Crowder, and Veresta Wilson. (State Archives of Florida, Florida Memory.)

The first school for students in the Gretna area was conducted in a church on the outskirts of town. As the railroad boomtown grew, it became necessary for a larger, dedicated schoolhouse to be built inside the township. Construction began on the two-story Gretna School building in 1908 on land purchased from the Humphrey and Mahaffey families. For 27 years, the bell in the steeple rang to let students know it was time for school. It was silenced in 1935, when the school closed and the students were sent to Quincy for their education. The building still stands, used by families of the original patrons as a private clubhouse. (GCHS.)

Gretna students stand with their principal for a portrait in 1910. Principal Robert Andrew (R.A.) Gray (far right), son of a Methodist minister, served in the state legislature representing Gadsden County before becoming Florida's secretary of state in 1930. He holds the distinction of being the longest-serving secretary of state, holding the position from 1930 to 1961. The R.A. Gray building in Tallahassee, which houses the State Library and the Museum of Florida History, is named in his honor. (GCHS.)

The entire student body of what is identified by the state archives as Greensboro School poses with its principal, Mr. Marsh (back row at far right) in this undated photograph. Apparently, this country schoolhouse sprouted wings and grew. The original building is seen at the center of the structure. With the county's growth came more families; this photograph illustrates how schools literally expanded to fill the educational needs of their communities. (SAF/FM.)

While it is hard today to imagine barefoot children attending school, this was the norm in the rural communities dotting Gadsden County in 1907. Farm children had very different lives from those raised in town, but almost all, given the chance, would have done the same as these children standing in front of Greensboro School. Older children, like those at the rear, were required to help, and became adults much sooner than their town counterparts. (SAF/FM.)

According to local legend, the community of Sawdust got its name from a large pile left from an old sawmill located on the west side of Hosford Road below the crossroads. The Sawdust School was located on the southwest corner of the crossroads. Seen with a group of students in this 1911 photograph is J.R. Key, superintendent of public education, in the back row at far right. (GCHS.)

Another fine example of a one-room schoolhouse was Shady Grove School in Dogtown. Standing to the right of the students is their teacher, Ed Dugger. (GCHS.)

The days of the one-room country schoolhouse were fading when Quincy High School (above) and Havana High School (below) were constructed in the early 1900s. These buildings, designed in the Second Renaissance Revival style, popular for public buildings at the time, featured balanced symmetrical facades and arched, recessed openings. Quincy High, designed by architect W.H. Carr and built by contractors Cooper & Selman, still stands today and serves as the headquarters of the Gadsden County Head Start pre-kindergarten program. Havana High burned down in 1925, was rebuilt in 1926, and was eventually demolished. The site is now a landscaped public park. (Above, courtesy of the authors; below, GCHS.)

Six
RURAL LIFE

Sycamore volunteers build tables and screens during a community "Working Bee" on July 30, 1935. The log-constructed building, and the land and all of the furnishings, were donated by members of the community. Annual community fairs sponsored by the Women's Home Demonstration Club and teachers of the Concord School were held at the Sycamore Community House. Farm-raised and home-canned products, as well as fancy work and other handmade crafts, were exhibited. (GCHS.)

Gadsden County Home Demonstration agent Elise LaFitte (center) teaches rug-making at the Quincy Women's Club building. (GCHS.)

In 1930, the first frozen food products became available to the American public after Clarence Birdseye's invention of packing fresh food into waxed cardboard boxes and then flash-freezing them under high pressure. In 1941, Solomon's Dairy offered that service to the Home Demonstration Clubs. Mrs. Fletcher Edwards's chickens, frozen at the dairy, became available for local retail sale. (GCHS.)

Agricultural extension work began in Gadsden County in 1912, when county agents were hired to travel to rural communities, teaching groups of women about the cultivation and canning of produce. In 1914, a full-time county agent was appointed and instruction was widened to include sewing, nutrition and health, poultry, and dairying. Club members participated in many community activities, such as demonstration tours and annual contests. They assisted in organizing several women's and 4-H clubs throughout the county. In 1925, Ruth McKeown, shown here, was Gadsden County's winning club girl at the state fair in Jacksonville with her exhibit of canned products. (GCHS.)

The Gadsden County delegation of Home Demonstration Club Short Course Girls look like they've had enough of "big city life" and are eager to return to their farms and chore duties. Photographed in front of the Wescott Building on the Florida State University campus are, from left to right, (first row) Dorothy Williams (Chattahoochee), Elise Peavy (Havana), Virginia Moore, Dixie Cook (Havana), Elise LaFitte (county extension agent), Suzie Williams (Chattahoochee), and Louise Rook (Chattahoochee); (second row) Dorothy Nettles (Sycamore), Dovie Glenn (Greensboro), Edelle McClane (Sawdust), Grace Ventry (Greensboro), Hattie Fletcher (Greensboro), Mildred Gunson (Concord), Martha Runkle (Chattahoochee), and Frances Shepard (Chattahoochee). (GCHS.)

Seven
Transportation and Industry

In the early 1800s, the river corridor was the dominant means of transporting agricultural products to market. The Chattahoochee-Flint-Apalachicola river system was one of the most important in the Southeast, with plantations extending for many miles on both sides of the rivers. Navigating the river was often dangerous business. Boiler explosions, fires, collisions, and a river full of snags contributed to the demise of many boats. The steamboat *Major George W. Wylly*, shown here, sank in 1884 after it hit a bridge pier, killing 18 people. (SAF/FM.)

Railroad men and workers stand before the charming Chattahoochee station, built in the Stick style, a popular mode of train station architecture in the late 19th century. The station, at River Junction, was the hub of the second-largest terminal in the state. (Courtesy of the Wiregrass Archives, Troy University Dothan Campus, Dothan, AL.)

Railroad expansion in Gadsden County created new towns that in turn required transportation for local industry. By 1909, Gretna's turpentine and timber interests were transported from the new Southern Express Company depot built alongside the Seaboard Air Line train route through the county. Simply clad in board-and-batten siding this little depot was typical of many found along the railways. (Courtesy of the authors.)

By 1900, a café and hotel were added to the Chattahoochee station at River Junction. Today, the town of River Junction is long gone. Following numerous fires and floods, businesses were forced to relocate to higher ground at Chattahoochee. The only vestiges of the once-bustling railroad town are the still-active freight tracks of the rail yard. (GCHS.)

A Seaboard Air Line steam locomotive, wood stacked in the tender, waits to connect a load of cars at River Junction, allowing railroad workers a moment to pose for this photograph. (Courtesy of the Wiregrass Archives, Troy University Dothan Campus, Dothan, AL.)

A new rail line was built in 1862, running east from Quincy, where it connected with the Florida Atlantic & Gulf Central between Lake City and Jacksonville. The line ultimately came under the control of the Seaboard Air Line in 1900, with the route running from Jacksonville to New Orleans. Passenger service as well as freight lines carrying Southern timber, minerals, and produce to Northern states made the completion of the railroad paramount for the progress of the county. (GCHS.)

Portions of Florida's old mission trail were transformed into the "Old Spanish Trail" (US 90), completed in 1929 amid fanfare and celebration. Tales of missions, forts, and Spanish explorers contributed to an exotic narrative of the new motorway. Rotary clubs and chambers of commerce competed to have "America's Highway of Romance" come through their towns. Stretching from St. Augustine to San Diego, its route brought travelers through Gadsden County and service stations, motels and restaurants benefited from the increased traffic. A welcome sign (above) at Quincy's city limits promoted local businesses. (Courtesy of the E.B. Embry Family Archives.)

The Victory Bridge, spanning the Apalachicola River at Chattahoochee, was dedicated on June 20, 1922. The first boat to pass under the bridge 20 minutes later was the *Callahan Jr.* (above). Construction of the bridge (below), along with the paving of the Old Spanish Trail (US 90), placed Chattahoochee firmly on the map as the east-west gateway on one of the most traveled roads in the state. (GCHS.)

In the late 1820s, John "Virginia" Smith and William S. Gunn settled in Gadsden County. They were the first growers of Virginia-seed tobacco in this region. Arthur Forman shipped the first Florida leaf to Germany 20 years later, and, with great success, shipments continued until the Civil War. In 1886, Col. Henry R. Duval, descendant of Florida's first territorial governor and president of the Florida Central & Peninsula Railroad (Seaboard), planted tobacco sent from

Circling the square's west side in 1920 are tobacco-laden wagons en route to warehouses. Cotton sheets protect the contents as the wagons pass the F.P. May Drugstore on Adams Street (at center). To the left are three buildings replaced by the 1922 Masonic Temple, including an antebellum Greek Revival office and corner store, its windows covered by sheathing. (Courtesy of the Josephine Gossett Phillips family.)

the island of Sumatra. The next year, he sent the Gadsden-grown leaf to New York dealers and cigar manufacturers. Word got out about this high-quality tobacco leaf, and in 1887, Straiton & Storm, the world's largest tobacco firm, formed a new company, the Owl Commercial Company. W.M. Corry was sent by the company to Gadsden County to organize, purchase, and manage its vast operations. (Courtesy of the First Presbyterian Church, Quincy.)

Ignatz Gardner (center), head of purchasing for the American Sumatra Tobacco Company, is pictured with a 14-ox team beside the Florida Havana & Sumatra Tobacco Company in the late 1890s. (SAF/FM.)

D. Alexander Shaw, manager of the firm Schroeder & Bon, is credited with constructing the first wooden shade over the tobacco in the spring of 1896. Using this method of laying wood slats over a network of wooden supports and wire, 40,000 slats were required to cover one acre of tobacco. (SAF/FM.)

TOBACCO GROWING UNDER SLAT AND CHEESE-CLOTH SHADE, QUINCY, FLA.

The introduction of cheesecloth proved to be the answer to successfully growing fine cigar tobacco in this area. Not only did it provide the shade necessary to create a thinner and finer texture of the leaves, but protected the crop from insects, rain, and hail. Brands using the Gadsden wrapper included White Owl, King Edward, Hav-A-Tampa, Florida Queen, Tampa Nugget, Lord Clifford, Budds, Tampa Straights, Swisher, Have-A Good, and Webbs Knock Outs. (Courtesy of the authors.)

Photographed in 1918, brothers Mark (center) and Lee Ray Munroe stand in front of the Big House of the Altschul Plantation with lifelong friend "Buddy" Bell (far right). Located between Scotland and Havana, the house was built expressly to entertain tobacco buyers. Guests would disembark from a private railroad siding and enter the house for lavish dinners in a surrounding that was state-of-the-art. A Delco-Light generator provided electricity and running water, unknown luxuries in rural Gadsden County. Added enticements included good bourbon, cigars, the latest 78s, and Savannah-style cooking. (Courtesy of the authors.)

From the fields, tobacco leaves were brought to the barns for curing. A labor-intensive process at all stages, the workers shown here stand at stringing stations. Behind them are uniform bundles of sticks used to string together a "hand" of tobacco. Leaves placed on the work surface would be hand strung through 30 to 40 tobacco stems to create the finished product, seen hanging at the left. These were then hung in the barn rafters to cure. (Courtesy of the authors.)

Magnus Delacy Peavy (center) and his farmhands stand in front of a tobacco barn in Havana, Florida. (SAF/FM.)

The longest-lasting name in Gadsden County's tobacco industry is the Wedeles Tobacco Company, founded in 1896 by Emile and Joe Wedeles and their cousin Max (foreground with dogs), all from Chicago. After Emile and Joe retired and returned to Chicago, the company became the Max Wedeles Tobacco Company. Former American Sumatra Tobacco Company purchasing manager Ignatz Gardner, seen seated in the third window from the left, became president upon Max's death in 1919. Following Gardner's death in 1943, management returned to the family when Joe Wedeles Jr. became president. The company name continued until 1976. (SAF/FM.)

Working in the modern era of tobacco growing, Don May (left) and brother Fount May check leaf samples at the May Tobacco Company warehouse in 1959. Bales of leaf ready for shipment to a cigar factory are on right. (SAF/FM; Karl E. Holland, photographer.)

In the late 1890s, an Alsatian worker at the Owl Commercial Company recognized clay extracted from a well being dug as Fuller's earth, a mineral also mined in Germany. William Corry, general manager of the company, sent a sample to Washington for analysis, and the discovery of Fuller's earth was confirmed. Surveys were conducted, locating millions of tons of deposits. Prized for its absorbent qualities, Fuller's earth is used to soak up oil, grease, and chemicals. In the granulated form, it is best known to most consumers as kitty litter. Fuller's earth has become a valuable commodity, and the Quincy mine is the nation's leading producer of the clay. (Courtesy of the authors.)

In the late 1920s, a growing need for hydroelectric power led to the construction of a dam and power plant at the Jackson Bluff Formation on the Ochlockonee River. As a result, an 8,800-acre reservoir formed in the floodplains above the dam. The new lake's proximity to the cities of Tallahassee and Quincy led to its name, Lake Talquin, home to recreational fishing and the Lake Talquin State Park. (SAF/FM, Herman Gunter, photographer.)

Members of the Rotary Club attend the opening of the Jackson Bluff hydroelectric power plant in 1929. (SAF/FM.)

Eight
SOCIAL LIFE AND LEISURE

The back of this postcard reads: "Cook's Fish Camp on Lake Talquin, 14 miles south of Quincy on Highway 267. Restaurant in Camp. Boats–Motors–Bait–Cabins with or without housekeeping facilities with vented gas heat, hot and cold water. Will accommodate two to eight in party. For Reservations write or wire John A. Cook, Route 3, Quincy, Florida." (Courtesy of the authors.)

Located in the heart of River Junction, the Hotel Marie (above) featured double verandas, as did the Gretna Hotel (below) where guests could relax and enjoy an evening of socializing or people-watching in the fresh air. (GCHS.)

Hotel The Bradley, River Junction, Fla.

In the late 1880s, River Junction was a bustling railroad town, the confluence of three major rail lines. The Bradley Hotel was located next door to the station. Featuring a walk-up lunch counter, the hotel served busy customers on the go and provided rooms for railroad personnel and travelers staying the night. (Courtesy of the authors.)

The town now known as Greensboro in western Gadsden County was originally nothing more than Green's Post Office, a mail stop serving the communities located near the property of J.W. Green. In 1907, when the Apalachicola Northern Railroad was constructed, Green's property was chosen as the site for a depot and station. Building lots were laid out, and a hotel and other businesses were soon established. The town was incorporated in 1909 and officially named Greensboro. The Greensboro Hotel, seen here, was built by James Dezell for partners J.W. Green and E.B. Fletcher, became the center of social life for the area. (GCHS.)

Visitors from as far away as Los Angeles, tobacco buyers from Chicago and New York, and governors and politicians from Tallahassee were among the high-class clientele of the Quincy Hotel. Elegant surroundings and first-class meals were the main attractions of the three-story hotel built in 1907, Comfortable rocking chairs lured guests onto the double veranda. It was not unusual to see guests such as Joan Crawford, Judy Garland, or a member of the wealthy Rothschild family passing through town on their way to Palm Beach. Gen. George Patton spent a week at the hotel in the early 1940s on a fishing vacation. Facing declining business, the hotel was demolished in the early 1960s. (Courtesy of the authors.)

Built around 1900, the Elk's lodge (above), east of the courthouse, was situated on a hilly, wooded spot. The rustic lodge featured a two-story veranda wrapping around all four sides. Community events, such as the Elks' annual Easter egg hunt or meetings of the Athletic Club (below), were held in the building and on the grounds. The lodge was removed in the 1950s and replaced with the modern Gadsden County Hospital. Lumber from the lodge was used to build the American Legion Hall one block north on Washington Street. (Above, courtesy of the authors; below, GCHS.)

Lillian Springs, a pool and recreation area on the northwest outskirts of Quincy, was built around 1903 by A.J. Key and was named in honor of his wife, Lillian Bates Key. The popular picnic and swimming area was available to the public for a small fee. Area churches and clubs held picnics and events at Lillian Springs (above), and 4-H summer camp was held annually at the Springs (below). (Above, courtesy of the First Presbyterian Church, Quincy; below, GCHS.)

Hidden deep in a forest ravine on the northern edge of Quincy's residential suburb lies the abandoned site of the Burmah Springs pool. Built in the 1920s, the clear, cool, spring-fed pool and its bathhouse was a favorite spot on hot summer days. A diving platform and slide added to the fun. In the above photograph, childhood friends Lilla Parramore (left) and Margaret Munroe, showing off the latest swim fashions, bask in the sun after a cool dip in June 1931. A tragic accident closed the pool for good. Today, few people remember its existence or even where it was located. (Courtesy of the Claire Munroe Bates family.)

Popular entertainment in Quincy in the late 19th century included the annual arrival of the traveling circus. One of Quincy's most colorful citizens at the time was "Uncle" Tom Nathans, a retired circus performer. Nathans had traveled with several circuses from 1821 to 1842 as a comic singer, performing monkey and pony acts and wild-animal handling. Upon retiring, he opened a candy and school supply store in downtown Quincy. In the 1920s, traveling carnivals were still popular attractions, delighting young and old alike with amusements such as "Midget Village, Land of the Little People" (left) and "The Vampire Lucelle" (below). (Left, SAF/FM; below, courtesy of Josephine Gossett Phillips family.)

With the growing popularity of football at the turn of the 20th century, Gadsden schools developed sports programs. In the above photograph from around 1922, a crowd gathers behind Quincy High School for a postgame rally following the matchup between rivals Quincy and Havana. Below, the pumped-up Dunbar School offense poses in their uniforms and leather helmets. (Above, courtesy of the Josephine Gossett Phillips family; below, SAF/FM.)

Frank Shaw must have felt like he was the luckiest boy in town, sitting atop a fine pony in front of his house on West Washington Street. His father, C.R. Shaw Sr., and little sister Jessie wait to embark on a Sunday carriage ride. (Courtesy of the Mortimer B. Bates Jr. family.)

Sisters Olive and Jessie Shaw hold tight to the reins of their billy goat while cradling their favorite dollies, making sure they are safe in the cart. (Courtesy of the Mortimer B. Bates Jr. family.)

The Empire Theatre was located in the Fireman's Hall, one-half block from the courthouse square on East Jefferson Street. Built in 1900, it was the community center for musical and theatrical entertainment. (GCHS.)

Music and theater productions have always been popular entertainment in Gadsden County, illustrated here by Mortimer B. Bates Jr. portraying Huckleberry Finn and Mary Celia Davidson playing a delicate butterfly. Quincy's long succession of opera houses and theaters continues today; the last remaining movie theater, The Leaf, has been restored and converted to the Quincy Music Theatre. (Above, GCHS; below, courtesy of the Mortimer B. Bates Jr. family and the authors.)

A rare snowfall in Gadsden County occurred during the night of February 12, 1958. People in Quincy woke up the next day to nearly three inches of snow covering the town and did not waste any time building snowmen on the courthouse square (below). The photograph of the Munroe house on Jefferson Street (above) looks like a New England picture postcard. Few would guess the photograph was taken in Florida. (Courtesy of the Mortimer B. Bates Jr. family.)

Nine
GADSDEN CONNECTIONS

For many, Coca-Cola is Gadsden County's identity. Embellished through the years, the legend started with a friendship between Quincy banker M.W. Munroe and W.C. Bradley, Coca-Cola's first chairman. Original public shares of common stock were offered in 1919 at a cost of $40 and, like the myth, grew to unforeseen dimensions. Stories abound about the local banker's efforts to push the stock, and more than a few residents wished they had listened. An original share, dividends reinvested, would be worth over $9 million today. Here, a River Junction truck prepares to make its first deliveries of the iconic American beverage, Coca-Cola. (Courtesy of Charlton Keen Jr.)

Coming as a complete surprise to most locals, the USS *Gadsden*, named for Gadsden County, Florida, was launched on April 8, 1944. During World War II, she served in the Pacific Ocean theater for a short period as an assault cargo ship. After she was decommissioned, the *Gadsden* was specially equipped to carry railroad locomotives. In this photograph, 45 locomotives and tenders are lined up dockside, awaiting shipment to France for her maiden voyage as a US maritime vessel on November 1, 1946. (Courtesy of the authors.)

The destroyer USS *Corry*, launched on July 28, 1941, was the second ship named for Lt. Comm. William Merrill Corry Jr., a World War I officer. Corry, a Quincy native, served in France. After the war, while on a flight from New York, his plane crashed. Though he was thrown clear of the wreckage, Corry ran back to pull the other officer free of the flaming aircraft. Badly burned in the rescue, Corry later died from his injuries. He was posthumously awarded the Medal of Honor for his heroism and is remembered by the naming of the airfields at Pensacola and three ships in his honor. (SAF/FM.)

Gadsden County Honor Roll

Government and Politics

A.K. Allison, Florida's sixth governor
James E. Broome, Florida's third governor
Rivers H. Buford, Florida Supreme Court justice
R.H.M. Davidson, Florida senator and US congressman
Charles Dupont, Florida Supreme Court justice
Albert Waller Gilchrist, Florida's 20th governor
Alexander C. Lightbourn Sr., sergeant-at-arms of the Florida House of Representatives
Robert Meacham, Reconstruction-era African American state legislator and senator
Jonathan Robinson, first territorial judge and cobuilder of the first territorial capitol
Marcellus Stearns, Florida's 11th governor
James Harold Thompson, Florida Speaker of the House
Pat Thomas, president of the Florida Senate

Military

William M. Corry Jr., Congressional Medal of Honor recipient
Dr. John Henry Gee, Confederate commandant of Salisbury Prison
Gen. Ben Hodges, Army liaison to the US Congress

The Arts

Nat Adderly Jr., musician, Luther Vandross's arranger
Chris Clark, painter of the murals at Radio City Music Hall
Billy Dean, country music singer
Willy Holt, Academy Award nominee for production design and art directing
Alexander Key, artist and writer
Benjamin Knox, entertainer known as "The Lady Chablis"
Mark Lindquist, nationally known sculptor
Dean Mitchell, nationally known painter

Sports

Roger Bailey, professional baseball player
Jim "Cannonball" Butler, pro football player
David Debord, member of the 1970 Marshall football team
Milt Gray, professional baseball player
Mack Lee Hill, professional football player
Billy Ray Hobley, member for 22 seasons of the Harlem Globetrotters
Dexter Jackson, pro football player, MVP of Super Bowl XXXVII
Cutler Price AKA Jack Dillon, light heavyweight world champion boxer
Nathaniel Ruffin, member of the 1970 Marshall football team
Ernest Rodell Thomas, pro football player

The Professions

Dr. Thomas Y. Henry, grandson of Patrick Henry, director of medical stations of West Florida and Quincy during the Civil War
Hal Hentz, architect
Dr. Lasalle Lafalle, famous surgeon and past president of the American Cancer Society
Patricia Due, civil rights leader
Mary Ann Dupont Lines, cofounder of the nation's second-oldest college sorority, Phi Mu
Jerri Mock, first woman to fly solo around the world
Dr. Richard V. Moore, past president of Bethune-Cookman College
F. Tennyson Neely, Jules Vern's publisher
Hubert B. Sapp Jr., patent holder of the flash cube for Kodak
Leo Spitz, president of RKO and cofounder of Universal Studios

Discover Thousands of Local History Books
Featuring Millions of Vintage Images

Arcadia Publishing, the leading local history publisher in the United States, is committed to making history accessible and meaningful through publishing books that celebrate and preserve the heritage of America's people and places.

Find more books like this at
www.arcadiapublishing.com

Search for your hometown history, your old stomping grounds, and even your favorite sports team.

Consistent with our mission to preserve history on a local level, this book was printed in South Carolina on American-made paper and manufactured entirely in the United States. Products carrying the accredited Forest Stewardship Council (FSC) label are printed on 100 percent FSC-certified paper.

MADE IN THE USA